MOVIE ★ ICONS

PRESLEY

EDITOR
PAUL DUNCAN

TEXT
F. X. FEENEY

PHOTOS
THE KOBAL COLLECTION

TASCHEN

HONG KONG KÖLN LONDON LOS ANGELES MADRID PARIS TOKYO

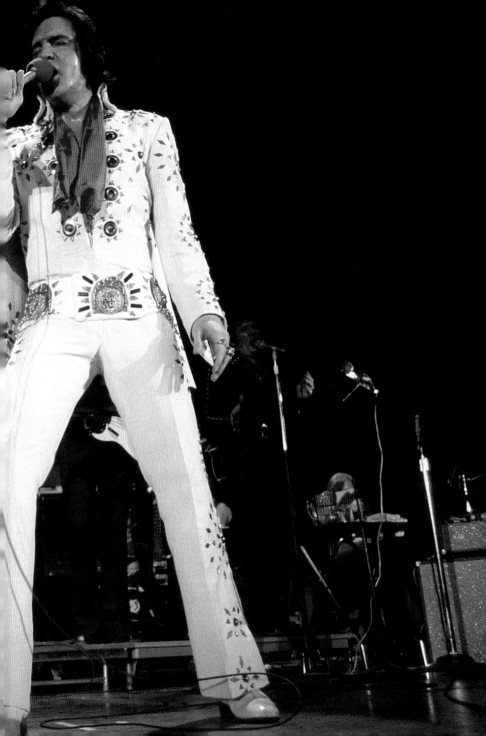

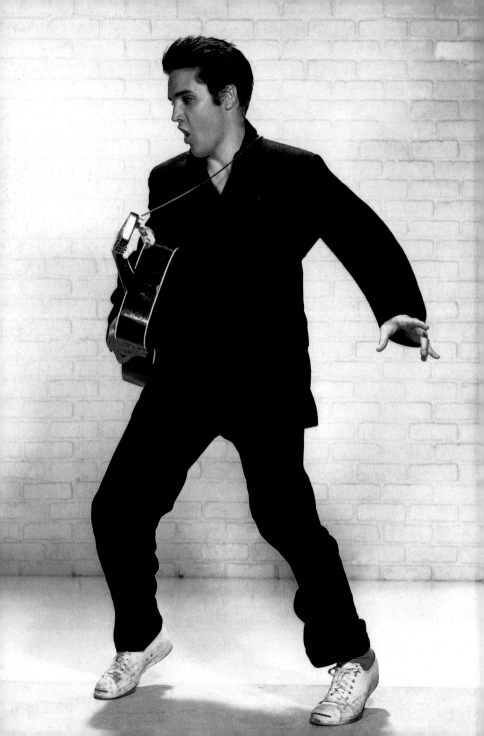

CONTENTS

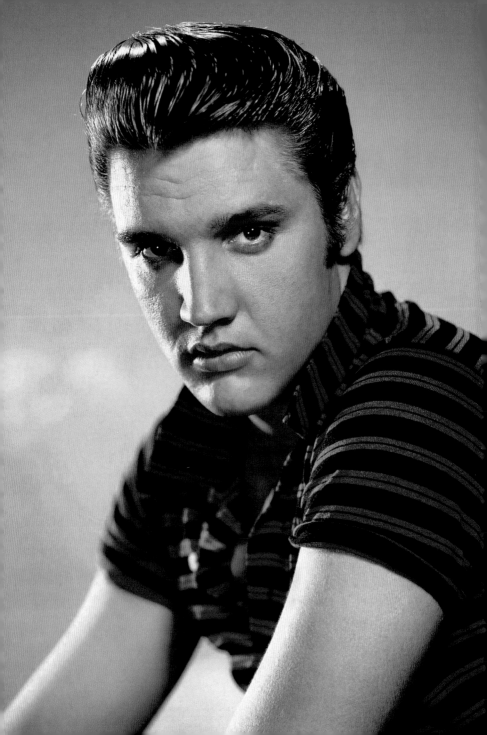

ELVIS PRESLEY: TENDER HEART

BY F. X. FEENEY

ELVIS PRESLEY: WEICHES HERZ

ELVIS PRESLEY : UN CŒUR TENDRE

ELVIS PRESLEY: TENDER HEART

by F. X. Feeney

Elvis Presley would have been the first to laugh at the mad, godlike status he attained after death, yet the first to empathize with the crazy, all-too-human need such adulation rises out of. He shared that need, and courted it throughout his life.

He was blessed with a pure gift – he could sing and move with a spellbinding mixture of violence and grace. He also had 'the listening presence' which marks great film stars. Even in the worst of his films, he exudes the gentle, baby-I-don't-care authority of his acting idol, Robert Mitchum, the confidence of one who has no need to call attention to himself – he *knows* he is interesting. Indeed, Elvis often seems more deeply interested in the person he is interacting with, be it Ann-Margret, a racecar mechanic, or a passing stranger. This endeared him to millions. (This is also the way actors best play Jesus on film, which, who knows, may help explain the messianic mystique Elvis has commanded in death.)

Born in a shack, raised dirt-poor by loving parents, Elvis had scant formal education, but from an early age displayed an exceptional singing voice. At age 18, he was driving trucks in Memphis, Tennessee, when a music promoter named Sam Phillips (owner of Sun Records) overheard him sing, and offered him a contract. Phillips cultivated a rich array of soon-to-be great artists – Carl Perkins, Jerry Lee Lewis, Johnny Cash, among others – seeking a fusion of African and Scots-Irish sounds native to the American South, then untapped by popular culture. Convinced there was a fortune to be made in the combination, he saw that Elvis

PORTRAIT (1957)
Why call Elvis "The King"? At his prime, Mr. Presley's face looked fit for a marble bust or a Roman coin. /
Warum wird Elvis „The King" genannt? In seinen besten Jahren schien das Gesicht von Presley tatsächlich einer Marmorbüste oder einer römischen Münze würdig. /
Pourquoi appeler Elvis « Le King » ? Dans la fleur de l'âge, son visage aurait pu servir de modèle pour un buste en marbre ou une pièce de monnaie romaine.

"I get lonesome, sometimes. I get lonesome right in the middle of a crowd."
Elvis Presley

instinctively fused these sounds. Indeed, Elvis was so unprejudiced that at first, racist whites unsuccessfully sought to ban his records and blight his career.

From the moment his first official recording, 'That's All Right, Mama,' hit the charts he was a sensation. Within the next 18 months he recorded a number of bluesy, snappy, rocking, clock-stopping songs with Sun. (These are the very best of Elvis.) After, he accepted a clever but avaricious manager for life in Colonel Tom Parker, who launched him on a hugely successful movie career, and saw to it that the world was awash in Elvis dolls, Elvis pencils, and Elvis 'products' of every kind imaginable.

In 1958, Elvis' mother died, shortly after he was drafted into the Army. Though he was outwardly stoical at the loss, inwardly he was never the same. Gladys Presley gave him his music; it was she who had nurtured and freed that wild, electric, tent-Christian fury of movement, that permeable openness which made him charismatic. Elvis grew wealthy and iconically famous under the Colonel's guidance, yet without Gladys a deep laziness shadowed his creative gifts. His earlier movies, like *Love Me Tender* (1956), *Jailhouse Rock* (1957), *King Creole* (1958), and *Flaming Star* (1960), reveal a talent for acting as true as his singing voice, but beyond these demonstrations of exceptional potential, Elvis did little more than repeat himself, for the rest of his life.

Hints at a renewed Elvis surfaced in the late 1960s, after he married Priscilla Beaulieu (a beauty who physically could've been his female twin), fathered a daughter, and starred in a superb TV special which revealed that all the original fire was still there to be tapped. But these were mirages. The marriage ended; Elvis calmed his jitters with prescription drugs, surrounded himself with flatterers, and (most fatally) reinvented himself as a tacky Las Vegas performer in a white fringed jumpsuit. He died suddenly in August 1977.

Many blame his later downfall on the infamous dominance of Colonel Parker, but to do so overlooks that strange passivity at the heart of Elvis himself. Much as he was blessed with a great voice and a great fame, he was lost about what to do with either. This is only human. Perhaps it is this very humanness, writ large, that most deeply endears Elvis to the rest of us, we the six billion other fallible, gifted characters filling the planet.

ENDPAPERS /VOR- UND NACHSATZBLÄTTER /
PAGES DE GARDE
**STILL FROM 'ELVIS: THAT'S THE WAY IT IS'
(1970)**

PAGES 6/7
PORTRAIT FOR 'GIRLS! GIRLS! GIRLS!' (1962)

PAGES 2/3
STILL FROM 'ELVIS ON TOUR' (1972)

PAGE 8
PORTRAIT

PAGE 4
PORTRAIT (1957)

OPPOSITE /RECHTS /CI-CONTRE
PORTRAIT

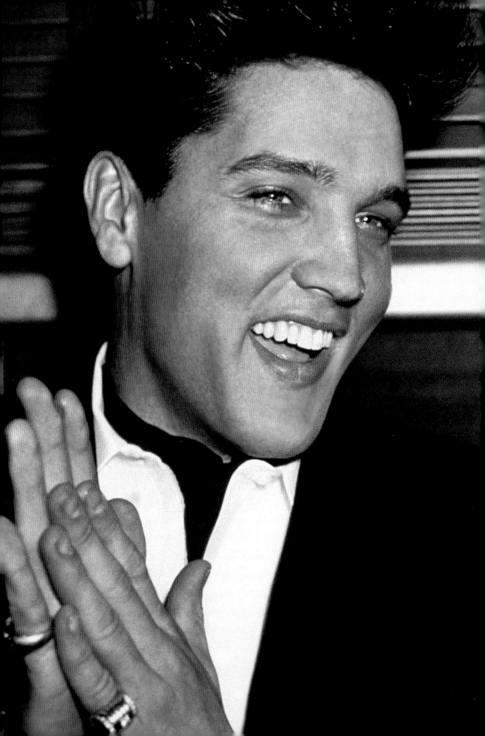

ELVIS PRESLEY: WEICHES HERZ

von F. X. Feeney

Elvis Presley hätte sicherlich sein Vergnügen gehabt an dem bizarren gottähnlichen Status, den er nach seinem Tod erlangte. Er hätte sich auch sehr wohl in jenes merkwürdige, doch allzu menschliche Bedürfnis hineinversetzen können, aus dem derartige Schwärmerei für ein Idol erwächst. Auch er hatte dieses Bedürfnis, und er trug ihm Zeit seines Lebens Rechnung. Er war mit einer besonderen Gabe gesegnet: Er konnte singen und sich mit einer faszinierenden Mischung aus Kraft und Anmut bewegen. Er besaß auch die Präsenz, die große Filmstars auszeichnet. Selbst in seinen schlechtesten Filmen verströmt er diese sanfte, bestimmende Lässigkeit seines Schauspielidols Robert Mitchum, die Selbstsicherheit eines Mannes, der es nicht nötig hat, auf sich aufmerksam zu machen, weil er *weiß*, dass er interessant ist. Tatsächlich scheint Elvis oft viel mehr an seinem jeweiligen Gegenüber interessiert zu sein, sei es nun Ann-Margret, ein Rennwagenmechaniker oder ein Passant. Das machte ihn zum Liebling von Millionen. (Auf diese Weise stellen Schauspieler auch Jesus am besten dar, was möglicherweise den messianischen Nimbus erklärt, der Elvis noch nach seinem Tod umgibt.)

Elvis, der in einer Hütte geboren und in ärmlichsten Verhältnissen von liebevollen Eltern großgezogen wurde, hatte kaum Schulbildung, besaß aber schon seit frühester Kindheit eine außergewöhnliche Singstimme. Mit achtzehn arbeitete er in Memphis (Tennessee) als Lastkraftfahrer, als ihn der Musikpromoter Sam Phillips, seines Zeichens Eigentümer von Sun Records, zufällig singen hörte und ihm einen Vertrag anbot. Phillips gab einer ganzen Reihe von Künstlern Starthilfe, die wenig später sehr berühmt wurden – unter anderem Carl Perkins, Jerry Lee Lewis und Johnny Cash. Er wollte die in den Südstaaten beheimateten afrikanischen und schottisch-irischen Musikstile miteinander verbinden, die von der Popkultur zu jener Zeit noch weitgehend unentdeckt waren. Phillips war fest davon überzeugt, dass man mit dieser Kombination ein Vermögen machen konnte, und erkannte, dass Elvis diese Klänge ganz instinktiv miteinander verschmelzen ließ. Elvis war dabei tatsächlich so unvoreingenommen, dass weiße Rassisten anfangs versuchten, seine Karriere auszubremsen und seine Platten verbieten zu lassen.

„Ich fühle mich manchmal einsam. Manchmal fühle ich mich einsam inmitten einer Menschenmenge."
Elvis Presley

Von dem Augenblick an, in dem sein erster Song „That's All Right, Mama" Einzug in die Charts hielt, war er eine Sensation. Innerhalb der nächsten achtzehn Monate nahm Elvis eine Vielzahl eingängiger, fetziger, rockiger, bluesartiger Songs bei Sun auf, die ihn von seiner allerbesten Seite zeigen. Danach ließ er sich mit dem geschickten, aber auch geldgierigen Colonel Tom Parker ein, der ihn bis zu seinem Lebensende als Manager begleitete, ihm zu einer ungemein erfolgreichen Filmkarriere verhalf und dafür sorgte, dass die Welt mit Elvispuppen, Elvisbleistiften und Elvisprodukten jeder nur erdenklichen Machart überschwemmt wurde.

1958 verstarb Elvis' Mutter, kurz nachdem er zum Militärdienst eingezogen worden war. Obwohl er sich äußerlich nichts anmerken ließ, war er innerlich tief erschüttert. Gladys Presley hatte ihn zur Musik gebracht, sein Talent gefördert und das unbändige Temperament, das man von christlichen Zeltpredigern kannte, in ihm freigesetzt, jene transparente Offenheit, die sein Charisma ausmachte. Elvis gelangte unter der Führung des Colonels zu Wohlstand und wurde zu einer Ikone, aber ohne Gladys wurde seine künstlerische Begabung von einer tiefsitzenden Trägheit überschattet. Seine frühen Filme – wie *Pulverdampf und heiße Lieder, Rhythmus hinter Gittern, Mein Leben ist der Rhythmus* und *Flammender Stern* – verrieten ein schauspielerisches Talent, das so echt war wie seine Singstimme, aber außer diesen Zeugnissen außergewöhnlicher Möglichkeiten tat Elvis bis zu seinem Tod nur wenig mehr als sich zu wiederholen.

Ende der sechziger Jahre deutete sich eine Erneuerung an, nachdem er Priscilla Beaulieu (eine Schönheit, die physisch seine Zwillingsschwester hätte sein können) geheiratet und eine Tochter gezeugt hatte und zudem in einem herausragenden Fernsehspecial aufgetreten war, das zeigte, wie sehr das Feuer seiner Anfangsjahre noch immer in ihm loderte. Aber diese Erfolge entpuppten sich rasch als Strohfeuer. Die Ehe ging in die Brüche, Elvis bekämpfte seine innere Unruhe mit Medikamenten, umgab sich mit Schmeichlern und inszenierte seine eigene Auferstehung als kitschige Las-Vegas-Nummer im weißen Overall mit Fransen. Er starb unvermutet im August 1977.

Viele geben der berüchtigten Dominanz von Colonel Parker die Schuld an Presleys späterem Untergang, aber sie übersehen dabei die merkwürdige Passivität von Elvis selbst. So sehr er auch mit einer tollen Stimme und großem Ruhm gesegnet war, so wenig verstand er mit beidem umzugehen. Aber das ist menschlich. Und vielleicht ist es gerade diese Menschlichkeit, die uns Elvis so verbunden macht – uns, den sechs Milliarden anderen fehlbaren Talenten, die diesen Planeten bevölkern.

STILL FROM 'VIVA LAS VEGAS' (1964)
Elvis met his charismatic match in singer-dancer Ann-Margret. / Elvis fand in der Sängerin und Tänzerin Ann-Margret ein Gegenüber, das ihm in Sachen Charisma ebenbürtig war. / Elvis rencontre son double charismatique en la meneuse de revue Ann-Margret.

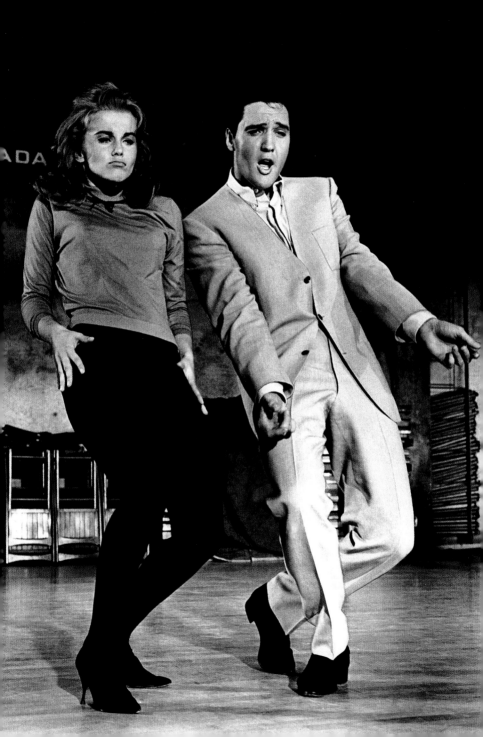

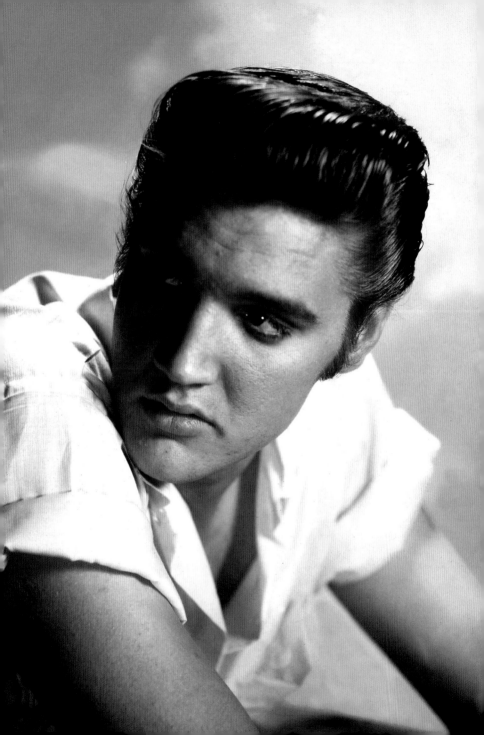

ELVIS PRESLEY : UN CŒUR TENDRE

F. X. Feeney

S'il avait découvert le statut de demi-dieu qui fut le sien après sa mort, Elvis Presley aurait certainement été le premier à en rire, mais aussi le premier à comprendre cette soif folle et terriblement humaine d'aduler des stars. Il ressentait cette soif et a cherché à l'étancher tout au long de sa vie.

À la naissance, Elvis reçoit un don des dieux : chanter et danser avec une grâce et une violence ensorcelantes. Il a aussi cette «présence attentive» qui est l'apanage des grandes stars de cinéma. Même dans ses films les plus médiocres, il déborde de l'autorité nonchalante de son idole, l'acteur Robert Mitchum, de l'assurance d'un homme qui n'a pas besoin d'attirer les projecteurs sur lui parce qu'il *sait* qu'il ne laisse pas indifférent. Elvis semble particulièrement attentif à son interlocuteur, qu'il s'agisse de la meneuse de revue Ann-Margret, d'un mécanicien de voitures de course ou d'un inconnu qui croise son chemin. Cette attitude lui vaudra la ferveur de millions d'admirateurs. (C'est aussi en adoptant ce comportement que les acteurs incarnent le mieux le Christ à l'écran ; et si on tenait là, qui sait, une des clés de l'aura messianique qui a enveloppé Elvis à sa mort ?)

Né dans un taudis, Elvis est élevé dans la pauvreté par des parents aimants et reçoit une bien maigre éducation. En revanche, on lui découvre dès son plus jeune âge une voix exceptionnelle. Âgé de 18 ans, il travaille comme chauffeur routier pour une société de Memphis dans le Tennessee lorsqu'un dénicheur de talents, Sam Phillips (propriétaire de Sun Records), l'entend chanter et lui propose un contrat. Phillips a déjà plusieurs petits protégés plus que prometteurs : Carl Perkins, Jerry Lee Lewis, Johnny Cash — pour ne citer qu'eux. Il est à la recherche de sons africains et irlando-écossais du sud des États-Unis, encore inexploités par la culture populaire. Convaincu qu'un tel mélange est la clé de la fortune, il décèle chez Elvis un don instinctif pour combiner ces sons. En effet, le jeune homme n'a aucun parti pris vis-à-vis de la culture

PORTRAIT
Elvis inspired a generation of imitators with his long sideburns, and high oily "sidewalls." / Mit seinen langen Koteletten und seiner mit viel Pomade auftoupierten Frisur inspirierte Elvis eine ganze Generation von Imitatoren. / Avec ses favoris et sa banane luisante de gel, Elvis a inspiré toute une génération d'imitateurs.

«Parfois, je me sens seul. Je peux me sentir seul tout en étant au beau milieu de la foule.»
Elvis Presley

noire, si bien que dans les premiers temps, les Blancs racistes essayeront en vain d'empêcher la vente de ses disques et de freiner sa carrière.

Dès l'instant où son premier titre officiel «That's All Right, Mama» se retrouve au hit-parade, Elvis fait sensation. Au cours des dix-huit mois suivants, il enregistre avec Sun Records un grand nombre de chansons de blues ou de rock, entraînantes et intemporelles (sans doute ses meilleures chansons). Quelque temps plus tard, il accepte de prendre un manager à vie, un homme rusé et d'une grande avarice, le colonel Tom Parker. Celui-ci le propulse au cinéma et la carrière d'acteur d'Elvis est couronnée de succès. Le «Colonel» veille aussi à ce que les fans ne soient pas en manque de poupées, stylos et articles en tout genre à l'effigie de sa star.

En 1958, après la mort de sa mère, Elvis est appelé sous les drapeaux. Même s'il ne laisse rien paraître de son immense chagrin, il ne se remettra jamais totalement de ce deuil. Gladys Presley lui inspirait sa musique, elle avait aidé son fils à laisser libre cours à sa danse pleine de ferveur et de frénésie, à exprimer son côté accessible et sensible qui faisait tout son charisme. Parvenu à un statut de star, Elvis poursuit son ascension sous la férule du colonel Parker, mais l'absence de Gladys a jeté une ombre sur son talent créatif, si bien qu'Elvis est peu enclin au travail. Ses premiers films, notamment *Le Cavalier du crépuscule* (1956), *Le Rock du bagne* (1957), *Bagarres au King Creole* (1958) et *Les Rôdeurs de la plaine* (1960), révèlent un talent d'acteur aussi certain que la qualité de sa voix, mais Elvis se contentera tout le reste de sa vie de tourner encore et encore des variantes d'un même film, laissant entrevoir ici et là un potentiel étonnant.

À la fin des années 1960, son mariage avec Priscilla Beaulieu (une très belle femme que l'on pourrait prendre pour sa sœur jumelle), la naissance de leur fille et son apparition dans une émission de télévision haute en couleur annoncent un tournant. Elvis démontre qu'il n'a rien perdu de sa superbe des premières années ; mais ces soubresauts ne sont qu'illusions. Son couple va à vau-l'eau ; Elvis calme ses paniques à grand renfort de médicaments, s'entoure de flatteurs et — plus dramatique encore — s'invente sur une scène de Las Vegas un personnage pathétique accoutré d'une combinaison à franges. Il meurt soudainement en août 1977.

Nombreux sont ceux qui imputent le déclin de ses dernières années à la domination sordide du colonel Parker, mais attribuer tous les malheurs d'Elvis à cet homme reviendrait à ignorer cette singulière passivité propre à l'artiste. Sa voix unique et son immense renommée n'avaient d'égale que son incapacité à les exploiter. Un défaut très humain, en somme. C'est peut-être son caractère profondément humain qui rend Elvis si attachant aux yeux du public, aux yeux des six milliards d'êtres potentiellement doués mais imparfaits qui peuplent la planète.

PAGE 22
STILL FROM 'JAILHOUSE ROCK' (1957)
Rocking the jailhouse, and the world. Few things communicated joyous rebellion faster than these gyrations. / Er brachte nicht nur den Knast in Schwung, sondern die ganze Welt. Man konnte ausgelassene Aufsässigkeit kaum besser auf den Punkt bringen als durch diese Hüftbewegungen. / Il bouscule le bagne … et le monde. Peu de choses communiquent une joyeuse rébellion aussi vite que ses déhanchements.

PORTRAIT
A cleaner-cut, "Vegas-friendly" Elvis, circa the mid 1960s. / Ein ordentlich frisierter, „vegasfreundlicher" Elvis um die Mitte der 1960er Jahre. / Avec sa coupe plus sobre, Elvis fait très «Las Vegas» au milieu des années 1960.

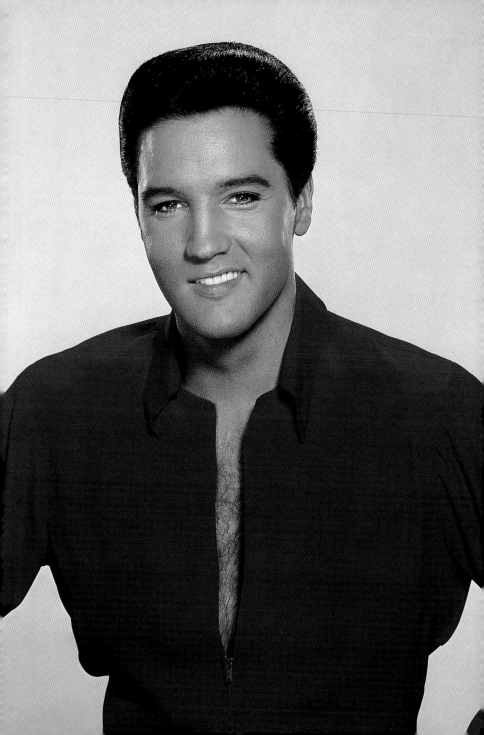

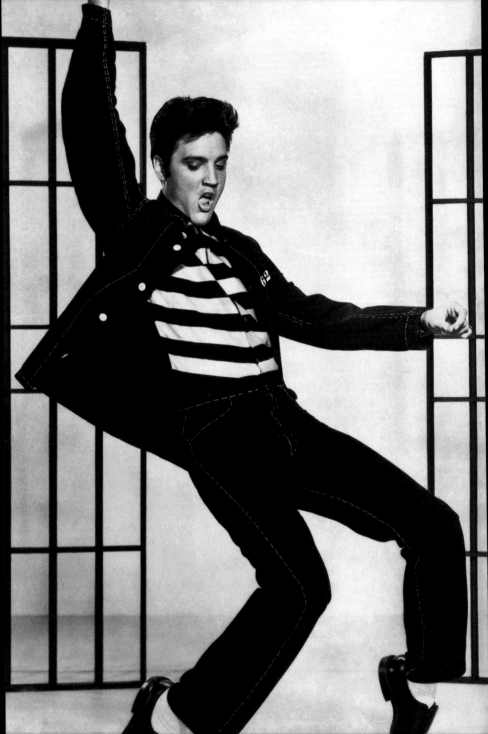

VISUAL FILMOGRAPHY

FILMOGRAFIE IN BILDERN

FILMOGRAPHIE EN IMAGES

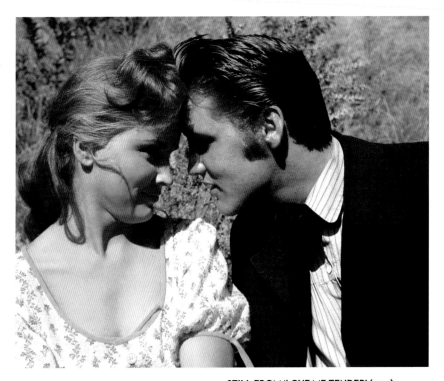

STILL FROM 'LOVE ME TENDER' (1956)
He sparked with Debra Paget on camera, but she
resisted his advances offscreen. / Auf der Leinwand
funkte es zwischen Elvis und Debra Paget, aber privat
wies sie seine Avancen zurück. / Face à la caméra,
Debra Paget et Elvis font des étincelles. Mais elle
résistera à ses avances hors plateau.

STILL FROM 'LOVE ME TENDER' (1956)
Elvis admired Robert Mitchum, and emulated the
actor's surly cool in his own first screen performances. /
Elvis bewunderte Robert Mitchum und ahmte die
mürrische Distanziertheit des Schauspielers in seinen
ersten Kinorollen nach. / Elvis admire Robert Mitchum
et imite l'indifférence hargneuse de l'acteur dans ses
premières apparitions à l'écran.

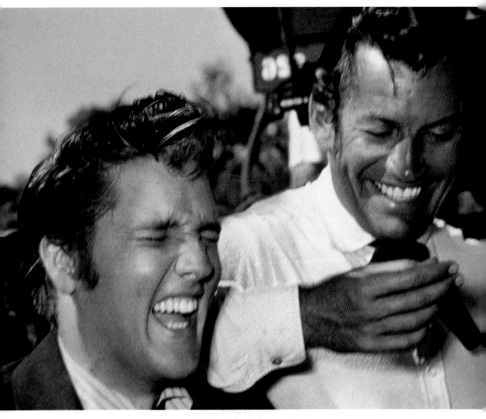

ON THE SET OF 'LOVE ME TENDER' (1956)
Richard Egan (right) was the established star. For
the only time in his career, Elvis took second billing. /
Richard Egan (rechts) war hier der etablierte Star, und
Elvis wurde — zum ersten und letzten Mal in seiner
Filmkarriere — an zweiter Stelle genannt. / Richard Egan
(à droite) est la star du moment. Pour la seule fois de sa
carrière, Elvis ne tient pas le haut de l'affiche.

*"How am I as an actor? Pretty bad. In some scenes
I was natural, but in others I was 'trying to act,' and
when you start trying to act, you're dead."*
Elvis Presley

*„Wie ich als Schauspieler bin? Ziemlich schlecht.
In einigen Szenen hab ich mich natürlich gegeben,
aber in anderen hab ich nur versucht, ‚zu schau-
spielern', und wenn du damit erst einmal anfängst,
dann bist du geliefert."*
Elvis Presley

*« Comment suis-je en tant qu'acteur ? Sacrément
mauvais. Je suis naturel dans certaines scènes,
mais dans d'autres, "j'essaie de jouer la comédie".
Et quand on "essaie de jouer", on est mort. »*
Elvis Presley

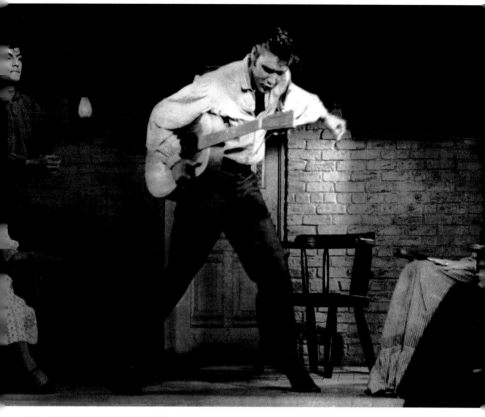

STILL FROM 'LOVE ME TENDER' (1956)
The tale takes place in 1865, but Elvis shows Egan and Paget that his musical style is a century ahead. / Die Handlung spielt zwar 1865, aber Elvis zeigt Egan und Paget, dass er seiner Zeit musikalisch um ein knappes Jahrhundert voraus ist. / L'histoire se déroule en 1865, mais Elvis prouve à Egan et à Paget que son style musical a bien cent ans d'avance.

PAGES 28–32
PAGES FROM MAGAZINE (1956)
From the very start, Elvis was news. Female fans loved knowing he was "lonely" — and available. / Vom ersten Augenblick an war Elvis in den Nachrichten. Seine weiblichen Fans liebten die Vorstellung, dass ihr Idol „einsam" — und „zu haben" — sei. / Depuis ses tout débuts, Elvis est un bon parti. Ses admiratrices jubilent à l'idée qu'il est « solitaire » ... et surtout célibataire.

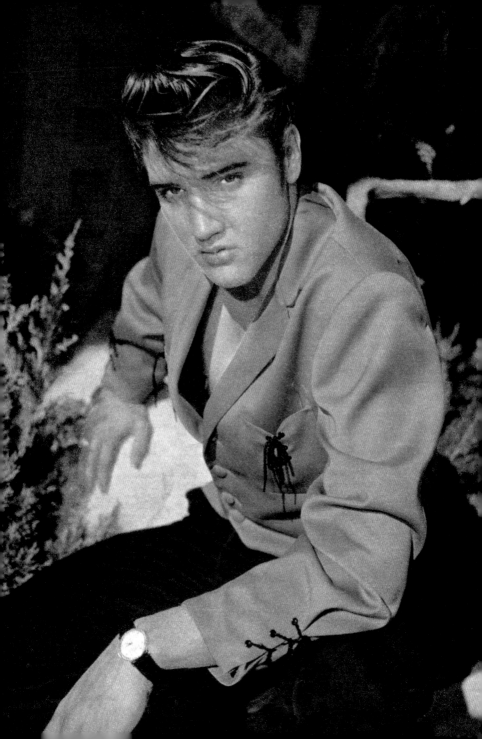

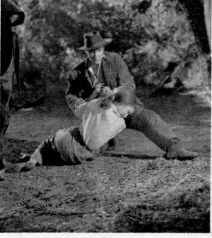

Explosive Elvis makes his screen debut in 20th's *Love Me Tender* with Debra Paget and Richard Egan. Before the picture was released so many complaints were made about Presley's death in the film, the studio found a way to soften the blow.

He came out of nowhere—this handsome, husky boy with his heart in his voice and his savagely passionate way of revealing his smouldering inner emotions—to give new meaning to the word *excitement* and become the biggest news of the year. "I don't fake," says Elvis. "I sing the way I feel, all the way." And the young people of America have responded by making him their Number One Idol. Two years ago Elvis paid three dollars to have the first of his twenty records made—last year he grossed over a million. The butt of criticism and censorship, accused of corrupting the morals of teenagers, Presley soared to the top, startling many staid, sober observers. No matter what anybody says the teenagers adore him. They laugh at accusations that he's vulgar. To them, he's an individual—unafraid to show his emotions, unafraid to sing the way he feels. Sure, he's got sex appeal, they say. "Man, he's the greatest!"

(Continued on next page)

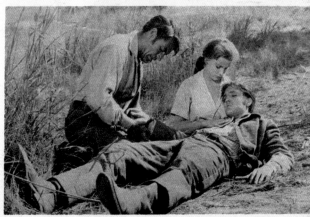

presley

elvis presley:

Fame...

and Loneliness

His closest friend is his guitar and his happiest moments are spent playing it and singing. His first guitar cost ninety-eight cents.

Life is wonderful for Elvis when he's with a crowd of people singing his heart out—but when he's alone, discontent, despondency and emptiness set

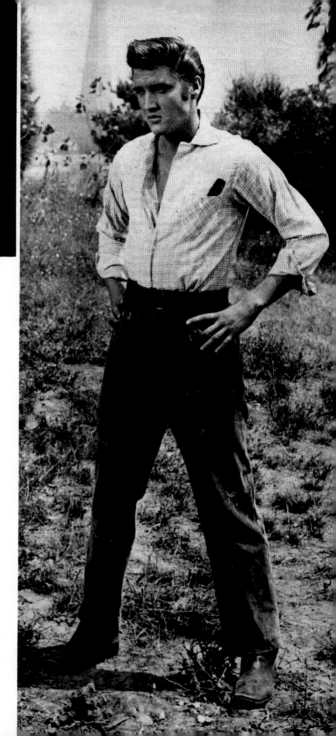

n Idol Finds

illions at his Feet,

o One by his Side

The curse that Elvis bears for his
rwhelming popularity is, ironically,
rible loneliness. Being constantly in
nand, he's always on the go and has
le time to establish lasting friend-
ps. Awe and jealousy also make close
s difficult. There are many who want
be his friend simply because they
e some of his glamour will rub off
them. Elvis senses the emptiness and
ility of such relations. He wants and
ds to be liked and understood as a
son, not as a phenomenon. When he's
home his family treats him as the
ne boy they knew and raised—but his
nces to visit his folks are very rare.
Iost men are inclined to resent the
cination Elvis holds for the girls. It's
ply a case of jealousy. But then,
at guy in his right mind would want
take a chance bringing his girl along
a double date with King Elvis? So
is is alone and lonely and he doesn't
e it. An hour by himself breeds the
content of having no one to share
ngs with. The Army may help, but
von't be easy to break down the bar-
r that fame has built up—the barrier
t sets Elvis as a man apart, a man
ne.

(Continued on next page)

Natalie Wood visits Elvis in Memphis, Tenn. Neither is interested in marriage—for now.

Carolyn Joseph from Elvis' home town would like to be the one and only in E Elvis doesn't want to feel "hooked" or tied down. He prefers carefree Nate

elvis presley:
His Love Life

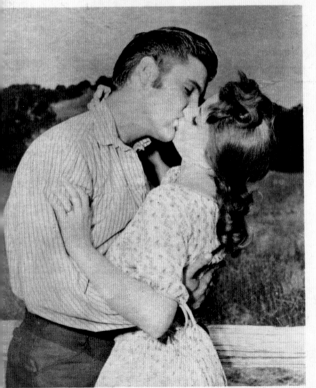

Debra Paget is his celluloid lover in *Love Me Tender*. Although they were good friends on location, no real romance blossomed. Elvis is searching for *the girl*.

Love is the Answer t

Loneliness He Feel

But Who's the Girl

■ "I guess I enjoy dating more th thing," Elvis says. And no wonde looking for the girl who will give me his life, make up for the lonely, hours he's spent. But Elvis plays t he wants to be careful. He gets fr away when a girl starts talking ma because when he takes the big step it to be his own decision. Don't try Presley around and don't try to sn He's a wild stallion that wants doesn't want to be tamed. Perhap why Natalie Wood is one of his dates. Natalie too, wants to keep the her finger for the time being. Like E loves fun and is game for anything exciting. Judy Powell Spreckels, fors of sugar heir Adolph Spreckels, II, other Presley date, adores him but enough not to tell the press—or Elvis town date, Carolyn Joseph, is too to hold Elvis. But somewhere ther girl to make his life complete. Tl

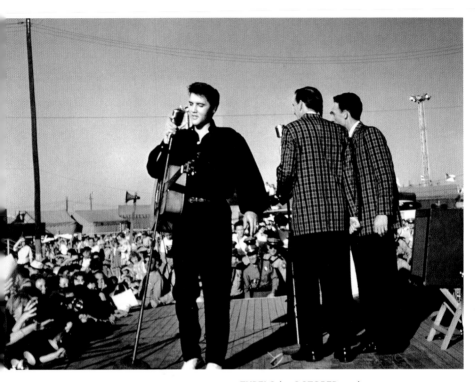

TUPELO (26 OCTOBER 1956)
A major concert, two months after signing with manager
Colonel Tom Parker. The flamboyant style hatched
early. / Ein großes Konzert, zwei Monate, nachdem er
von Colonel Tom Parker unter Vertrag genommen
wurde. Der extravagante Stil schälte sich schon früh
heraus. / Un concert déterminant pour sa carrière, deux
mois après la signature avec son manager, le colonel
Tom Parker. Son style flamboyant se manifeste très tôt.

A BOOMING
BOXOFFICE REPORT
FROM
PARAMOUNT!

ELVIS PRESLEY
IN HIS FIRST BIG, MODERN MUSICA
"LOVING YOU" IS SINGING UP
A STORM ACROSS THE NATION!

In Chicago, two tornadoes hit
last week! The Presley twister really
tore the town apart when it blew
into a sensational, record-breaking
50-theatre first run! In Tennessee,
Arkansas and Mississippi, it's toppin
everything ever! In New York, 82 first
showing engagements are rocking
the biggest city in the world with the
biggest boxoffice action in years!

A Hal Wallis Production
In Technicolor and VistaVision

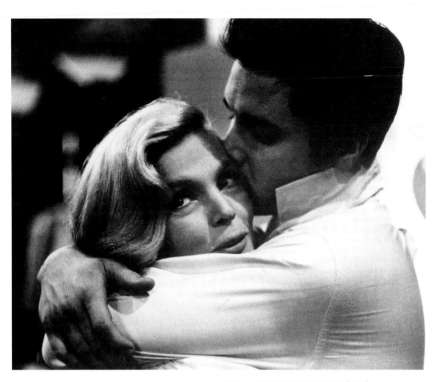

STILL FROM 'LOVING YOU' (1957)
Snuggling with Lizabeth Scott, his promoter in a yarn
about, yes, a truck driver with a forceful musical
talent. / Ein kuscheliger Moment mit Lizabeth Scott,
die seine Promoterin spielt in dieser Geschichte über
einen – man höre und staune – Lkw-Fahrer mit einer
großen musikalischen Begabung! / Blottie dans ses bras,
Lizabeth Scott incarne son attachée de presse dans
l'histoire d'un chauffeur routier – eh oui! – doté d'un
puissant talent musical.

ADVERT FOR 'LOVING YOU' (1957)
The detailed narrative smothers Elvis. His own
promoters could not believe the rapidity of his rise. /
Elvis geht in dem wortreichen Text fast unter. Seine
eigenen Promoter konnten das Tempo seines Aufstiegs
kaum fassen. / Sur cette affiche, Elvis disparaît
littéralement sous le texte promotionnel dithyrambique.
Ses propres agents étaient époustouflés par la rapidité
de son ascension.

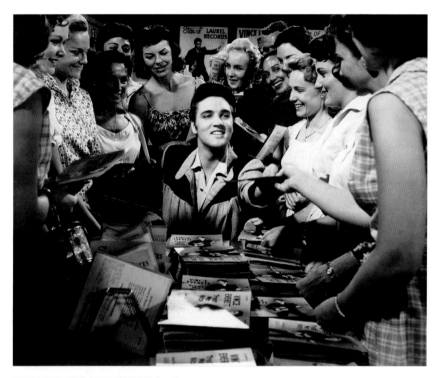

STILL FROM 'JAILHOUSE ROCK' (1957)
One of his best films: Elvis is an ex-convict set on going straight, using his enormous talent. / Einer seiner besten Filme: Elvis spielt einen ehemaligen Strafgefangenen, der sein gewaltiges Talent einsetzen möchte, um sein Leben wieder in geordnete Bahnen zu lenken. / L'un de ses meilleurs films : Elvis y joue le rôle d'un ancien détenu qui s'efforce de filer droit en s'aidant de son immense talent.

STILL FROM 'JAILHOUSE ROCK' (1957)
Locked up for accidentally killing a man in a barroom brawl, his worst enemy inside or out is his hot temper. / Nachdem man Vince (Elvis Presley) eingesperrt hat, weil er versehentlich bei einer Kneipenschlägerei einen Mann getötet hat, ist seine Heißblütigkeit nicht nur „draußen", sondern auch hinter Gittern sein ärgster Feind. / Incarcéré pour avoir tué accidentellement un homme dans une bagarre de bar, son pire ennemi semble être son tempérament colérique.

STILL FROM 'JAILHOUSE ROCK' (1957)
The man suffering his punch accidentally dies –
setting Vince (Elvis) on his hard road to rock 'n' roll
redemption. / Ohne Absicht befördert der Fausthieb
den Mann ins Jenseits und bringt Vince (Elvis) damit auf
den Weg zur Erlösung per Rock 'n' Roll. / L'homme qui a
encaissé son coup de poing meurt accidentellement.
Vince (Elvis) se retrouve sur le dur chemin de la
rédemption par le rock 'n' roll.

STILL FROM 'JAILHOUSE ROCK' (1957)
Before he gets in touch with his musical gifts, Vince
(Elvis) is punished for his excessive temper. / Bevor er
sich auf sein musikalisches Talent besinnt, wird Vince
(Elvis Presley) erst einmal für sein ungestümes
Temperament gezüchtigt. / Avant de découvrir ses dons
musicaux, Vince (Elvis) est puni pour son tempérament
excessif.

"I guess the first thing people want to know is why I can't stand still when I'm singing. It's just how this makes me feel. I can't sing with a beat at all if I stand still. Some people tap their feet, some people snap their fingers, and some people sway back and forth. I just started doing them all together, I guess."
Elvis Presley

„Ich denke, als erstes möchten die Leute immer wissen, warum ich beim Singen nicht stillstehen kann. So fühle ich mich einfach beim Singen. Ich kann überhaupt keinen Takt halten, wenn ich stillstehe. Einige Menschen wippen mit den Füßen, andere schnippen mit den Fingern, und wieder andere schaukeln vor und zurück. Ich habe bloß damit angefangen, das alles gleichzeitig zu tun, denke ich mal."
Elvis Presley

« Je suppose que la première chose que le public veut savoir de moi, c'est la raison pour laquelle je suis obligé de gesticuler quand je chante. C'est simplement que la musique me donne envie de bouger. Je ne peux pas du tout chanter en rythme si je me tiens immobile. Certains tapent du pied, d'autres claquent des doigts ou se balancent d'avant en arrière. J'imagine que je fais tout ça en même temps. »
Elvis Presley

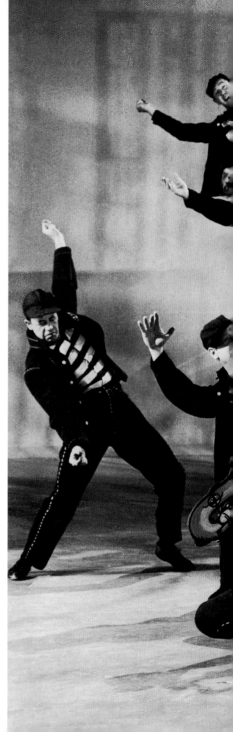

STILL FROM 'JAILHOUSE ROCK' (1957)
High-energy choreography and stage design, ideal for one of Elvis Presley's hottest, brightest songs. / Eine energiegeladene Choreographie und ein einfallsreiches Bühnenbild sind ideale Zutaten für die heißeste und fröhlichste Nummer, die Elvis in diesem Film bringt. / La chorégraphie endiablée et la configuration de la scène correspondent parfaitement à l'une des meilleures — et des plus sensuelles — chansons d'Elvis.

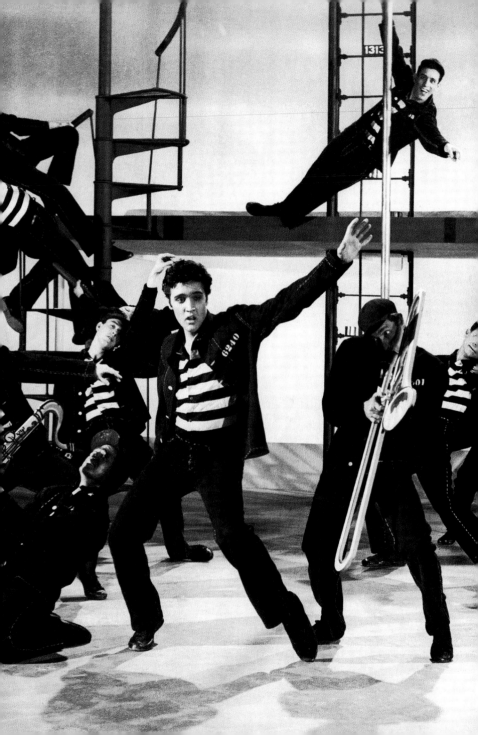

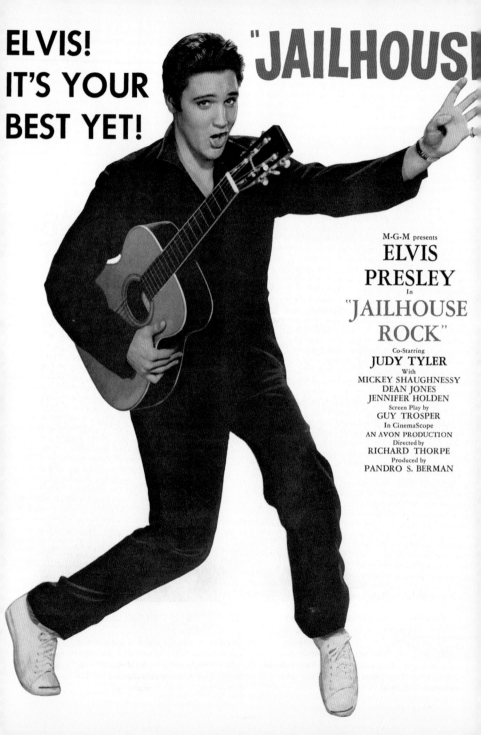

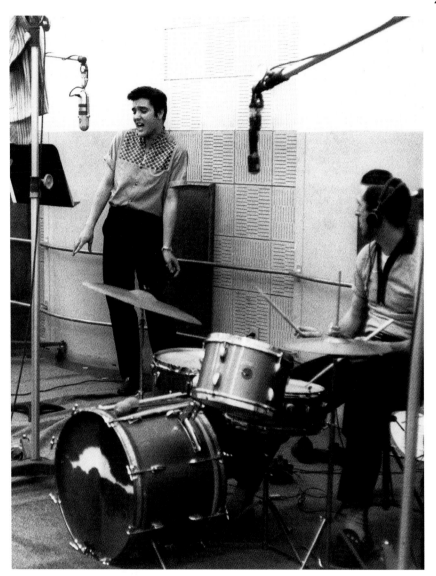

ADVERT FOR 'JAILHOUSE ROCK' (1957)
His gyrations earned him the nickname "Elvis the Pelvis," a nickname Elvis detested. / Seine Hüftschwünge brachten ihm den Spitznamen „Elvis the Pelvis" ein, den er verabscheute. / À cause de ses déhanchements, on l'appelle « Elvis le Pelvis », un surnom qu'il déteste.

RECORDING SESSION FOR 'JAILHOUSE ROCK' (1957)
He put his whole self, body, soul, and complete concentration into every song. / In jeden seiner Songs legte er sich ganz hinein — mit Herz und Seele. / Le King se donne corps et âme dans chaque chanson et fait preuve d'une concentration absolue.

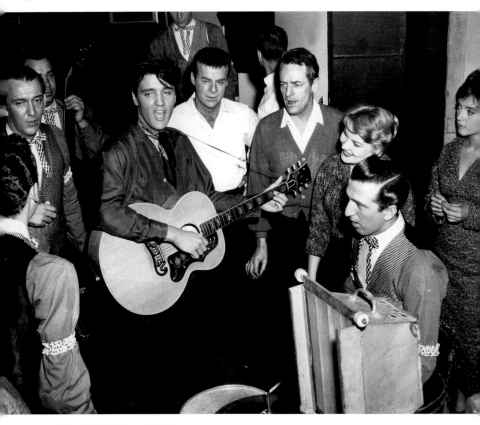

ON THE SET OF 'KING CREOLE' (1958)
When friends of actress Carolyn Jones visited the set,
Elvis gave an impromptu performance. / Als Freunde
der Schauspielerin Carolyn Jones bei den Dreharbeiten
vorbeischauten, lieferte ihnen Elvis eine Stegreif-
vorstellung. / Lorsque les amies de l'actrice Carolyn
Jones viennent visiter le tournage, Elvis leur offre un
petit tour de chant improvisé.

*"I want to entertain people. That's my whole
life – to my last breath."*
Elvis Presley

*„Ich möchte die Leute unterhalten. Das ist mein
ganzes Leben – bis zum letzten Atemzug."*
Elvis Presley

*« Je veux divertir les gens. C'est le but de ma vie
et je le ferai jusqu'à mon dernier souffle. »*
Elvis Presley

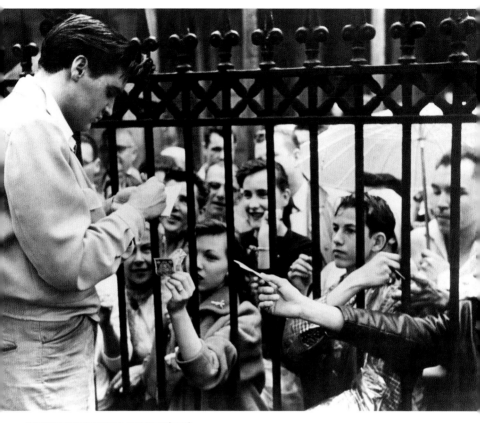

ON THE SET OF 'KING CREOLE' (1958)
Bars are needed to keep the fans at an arm's length
from Elvis. / Gitterstäbe sind nötig, um die Fans
wenigstens eine Armlänge von Elvis entfernt zu halten. /
Les barreaux sont nécessaires pour empêcher les fans
d'agripper Elvis.

PAGES 46 & 47
STILLS FROM 'KING CREOLE' (1958)
Elvis gets stabbed by thug Vic Morrow (left) and
rescued by a gangster's moll (Carolyn Jones). / Elvis
wird von Shark (Vic Morrow, links) niedergestochen
und von der Gangsterbraut Ronnie (Carolyn Jones)
gerettet. / Elvis se fait poignarder par un voyou, Vic
Morrow (à gauche), et est secouru par la maîtresse
(Carolyn Jones) d'un truand.

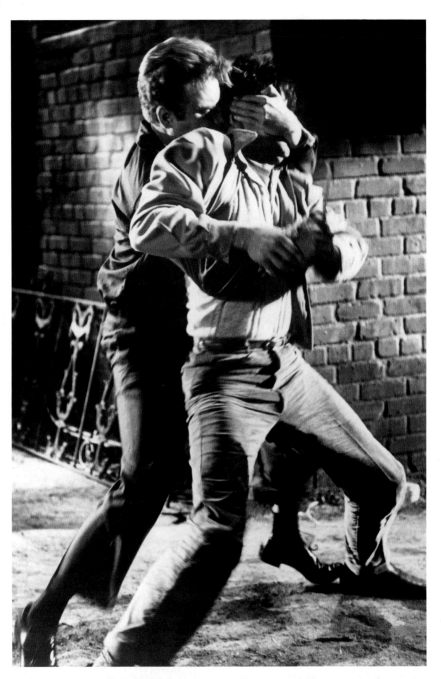

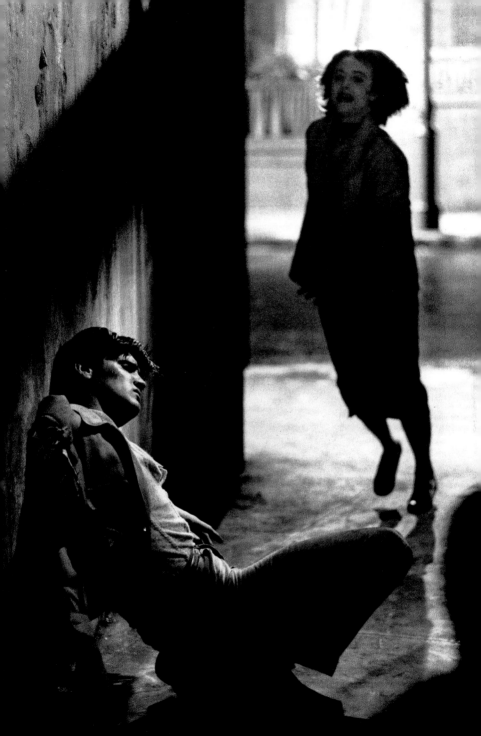

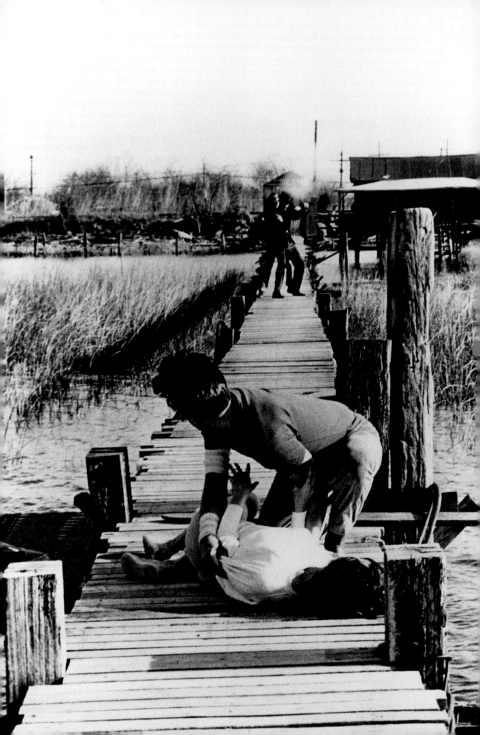

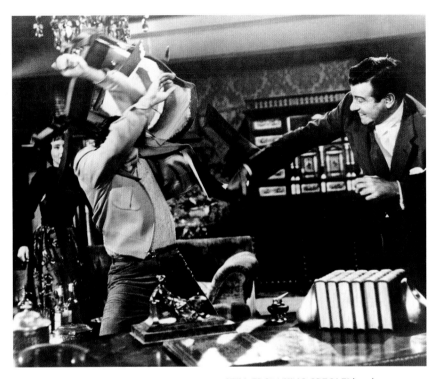

STILL FROM 'KING CREOLE' (1958)
Elvis goes on the warpath, in a brawl with crime boss Walter Matthau. / Danny (Presley) begibt sich auf den „Kriegspfad" und liefert sich eine Schlägerei mit dem Gangsterboss (Matthau). / Elvis sur le sentier de la guerre, dans une bagarre avec le patron du crime Walter Matthau.

STILL FROM 'KING CREOLE' (1958)
After saving Elvis, Jones is cut down by a bullet from her jealous lover (Walter Matthau). / Nachdem sie Danny (Presley) gerettet hat, wird Ronnie (Jones) von einer Kugel ihres eifersüchtigen Liebhabers (Walter Matthau) niedergestreckt. / Après avoir sauvé Elvis, Jones est touchée par une balle tirée par son amant jaloux (Walter Matthau).

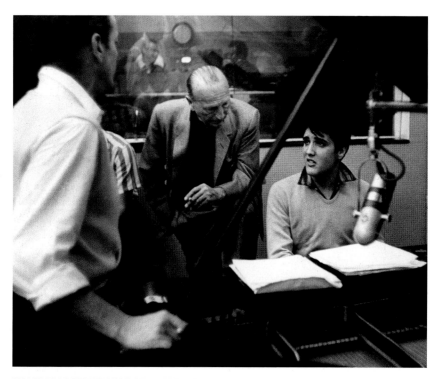

RECORDING SESSION FOR 'KING CREOLE'
(1958)
Best known for 'Casablanca,' master filmmaker Michael
Curtiz (center) directed Elvis in 'King Creole.' / In *Mein
Leben ist der Rhythmus* spielte Elvis unter der Regie von
Michael Curtiz (Mitte), der durch *Casablanca* berühmt
geworden war. / Séance d'enregistrement de *Bagarres
au King Creole* : plus connu pour son film *Casablanca,*
le réalisateur de renom Michael Curtiz (au centre) a
dirigé Elvis dans ce film.

RECORDING SESSION FOR 'KING CREOLE'
(1958)
Elvis got the best reviews of his film career for his work
here. / Für diese Arbeit erntete Elvis die besten
Kritiken seiner Filmkarriere. / Séance d'enregistrement
de *Bagarres au King Creole* : avec ce film, Elvis obtient
les meilleures critiques de toute sa carrière d'acteur.

PAGES 52/53
POSTER FOR 'G.I. BLUES' (1960)
After two years in the army, Elvis and his management
team decided to project a more "mature" image. / Nach
zwei Jahren in der Armee entschieden Elvis und sein
Management-Team, dass er sich fortan ein etwas
„reiferes" Image zulegen solle. / Après deux années
dans l'armée, Elvis, encouragé par ses agents, décide
de se donner une image plus « mature ».

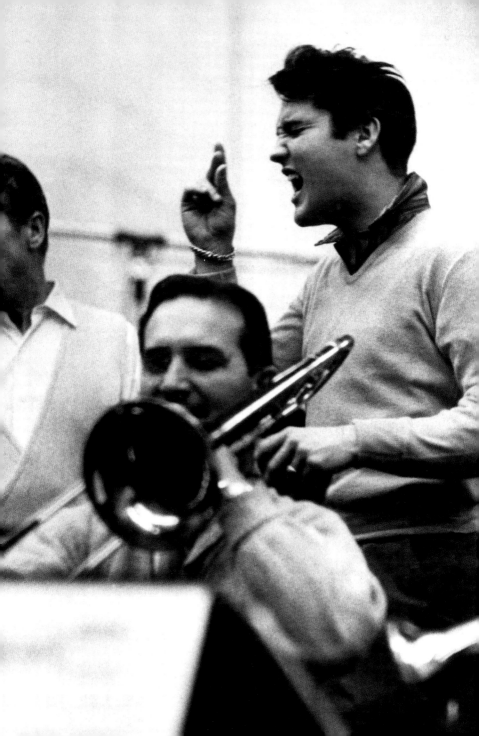

ฟัง 11 เพลงเอก
จาก
เอลวิส เพรสลีย์
ดูไป ฟังไป ดิ้นไป
จีไอบลูส์
G.I. BLUES

นิวไฟว์สตาร์
โทร. 816788 • 811800
จัดจำหน่าย

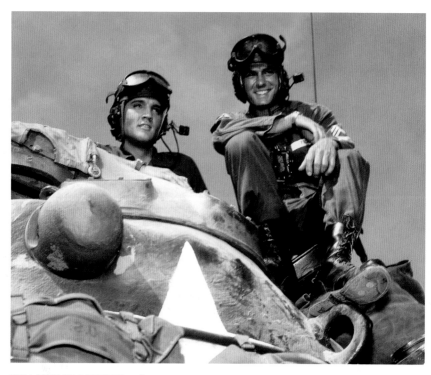

STILL FROM 'G.I. BLUES' (1960)
Elvis and his pals plan to pool their army wages to open
a night club in West Germany. Much music ensues. /
Tulsa (Elvis Presley) und seine Kameraden wollen ihren
Sold zusammenlegen, um in Deutschland einen
Nachtclub zu eröffnen. Natürlich wird viel Musik
geboten. / Elvis et ses amis projettent d'investir leurs
soldes dans l'ouverture d'une boîte de nuit en
Allemagne de l'Ouest.

STILL FROM 'G.I. BLUES' (1960)
His character's very name, "MacLean," evokes images
of soap and water, and Elvis "cleaning up his act." /
Schon sein Name, MacLean, klingt nach Seife und
Wasser (*clean* = „sauber"), ganz als ob Elvis hier auch
sein Image „bereinigte". / Le nom même de son
personnage, MacLean, évoque l'eau et le savon (angl.
clean, « propre ») et l'image d'un Elvis blanc comme
neige.

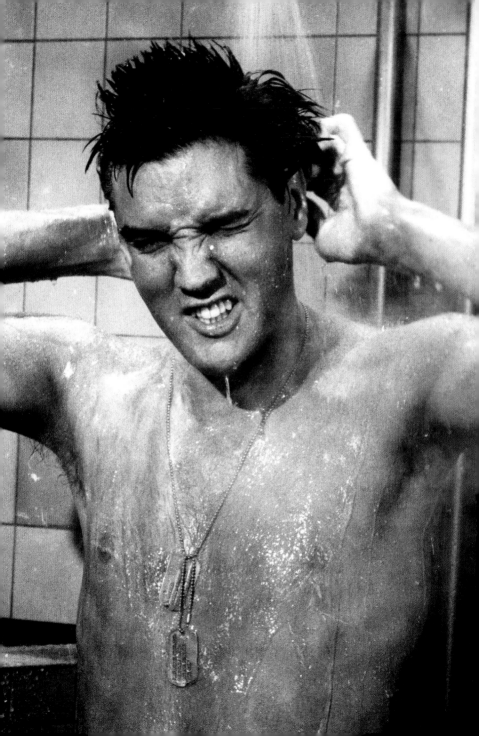

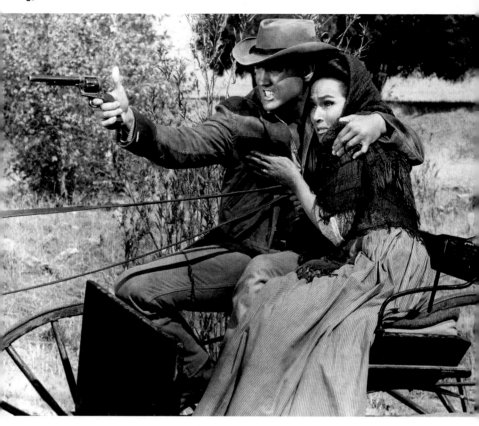

STILL FROM 'FLAMING STAR' (1960)
As a half-white/half-Kiowa, Elvis tries in vain to protect
his mother (Dolores Del Rio) from murderous whites. /
Als Kiowa-Halbblut versucht Pacer (Elvis Presley)
vergeblich, seine Mutter (Dolores Del Rio) vor weißen
Meuchelmördern zu schützen. / Incarnant un
personnage mi-Blanc, mi-Indien Kiowa, Elvis s'efforce en
vain de protéger sa mère (Dolores Del Rio) de Blancs
sanguinaires.

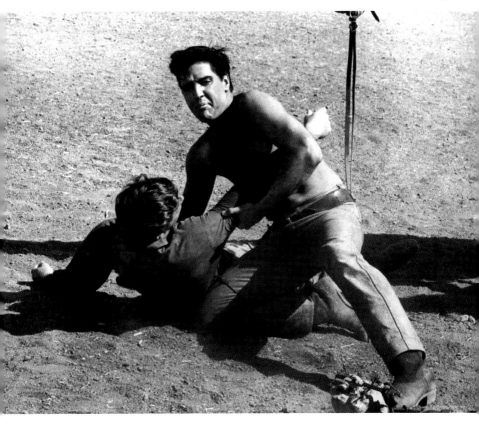

STILL FROM 'FLAMING STAR' (1960)
A fine film, directed by Don Siegel ('Dirty Harry')
and co-written by Nunnally Johnson ('The Grapes of
Wrath'). / Ein guter Film unter der Regie von Don Siegel
(*Dirty Harry*) nach einem Drehbuch, an dem Nunnally
Johnson (*Früchte des Zorns*) mitschrieb. / Un film de
qualité réalisé par Don Siegel (*L'Inspecteur Harry*) et
coécrit par Nunnally Johnson (*Les Raisins de la colère*).

*"When Elvis Presley first came to Hollywood to
make a movie, he came to see me. He was 21 and
a millionaire. He had seen James Dean in* Rebel
Without a Cause, *and he wanted to know more
about Jimmy. We were talking about movies, and
he said he didn't know how he could hit the actress
who was going to play opposite him. I said, 'Just
pretend you're slapping at a bothersome fly.' But
he said, 'No, I can't hit a woman!' and I suddenly
realized that it wasn't a question of motivation.
Elvis actually believed that he had to hit the girl
in this scene!
"He had to fight another actor, too, he said,
but he was in pretty good shape and thought he
could take care of him. I explained that you never
actually hit anyone in a movie, that it was all
faked ... Elvis was angry. He thought I was kidding
him; he couldn't accept the fact that he had been
deceived all these years by movies."*
Dennis Hopper

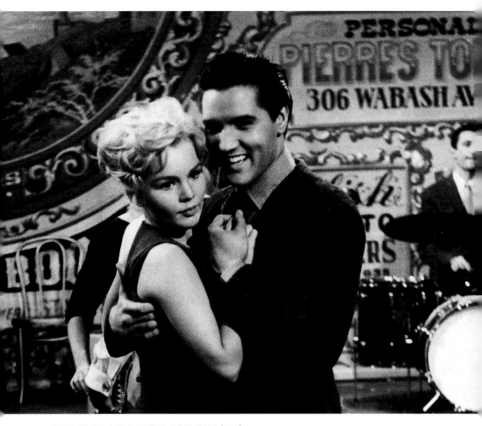

STILL FROM 'WILD IN THE COUNTRY' (1961)
A talented young man is tempted to while his life away
in the arms of a passionate cousin (Tuesday Weld). /
Ein begabter junger Mann gerät in Versuchung, sein
Leben in den Armen einer leidenschaftlichen Cousine
(Tuesday Weld) zu vergeuden. / Un jeune homme
talentueux est tenté de passer sa vie dans les bras de
sa tendre cousine (Tuesday Weld).

„Als Elvis Presley das erste Mal nach Hollywood
kam, um einen Film zu drehen, kam er mich
besuchen. Er war 21 und Millionär. Er hatte James
Dean in Rebel Without a Cause [... denn sie wissen
nicht, was sie tun] gesehen und wollte mehr über
Jimmy erfahren. Wir unterhielten uns über Filme,
und er sagte, er wüsste nicht, wie er seine
Filmpartnerin schlagen sollte. Ich sagte: ‚Stell dir
einfach vor, du haust nach einer Fliege, die dich
nervt.' Aber er antwortete: ‚Ich kann aber keine Frau
schlagen!' Da merkte ich, dass es gar keine Frage
der Motivation war – Elvis war der Meinung, er
müsste die Frau in dieser Szene wirklich schlagen!
Er müsste sich auch mit einem anderen
Schauspieler prügeln, sagte er, aber er sei ganz
gut in Form und würde wohl mit ihm fertig werden.
Da erklärte ich ihm, dass man im Film niemanden
richtig schlägt, dass alles nur getürkt ist. Da wurde
Elvis sauer. Er dachte, ich nähme ihn auf den Arm.
Er konnte es einfach nicht fassen, dass ihn das Kino
all die Jahre an der Nase herumgeführt hatte."
Dennis Hopper

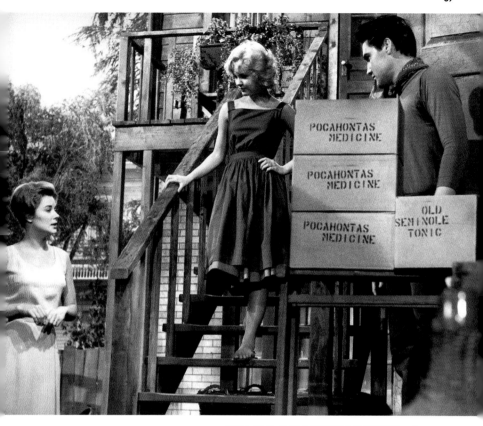

STILL FROM 'WILD IN THE COUNTRY' (1961)
His social worker (Hope Lange) encourages him to
pursue an education, but also falls for him. / Die
Sozialarbeiterin (Hope Lange) ermuntert ihn, sich
fortzubilden, erliegt aber ebenfalls seinem Charme. /
Son assistante sociale (Hope Lange) l'encourage à
poursuivre ses études mais ne peut résister au charme
du jeune homme.

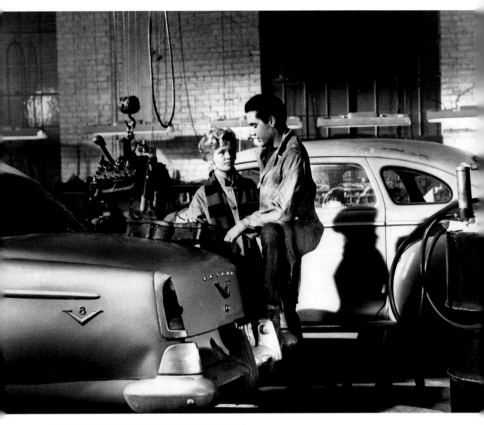

STILL FROM 'WILD IN THE COUNTRY' (1961)
Directed by Philip Dunne, written by Clifford Odets,
this would be Elvis' last ambitious performance. / Unter
der Regie von Philip Dunne und nach einem Drehbuch
des Dramatikers Clifford Odets war dieser Film
Presleys letzte ambitionierte Filmarbeit. / Le film est
réalisé par Philip Dunne et écrit par Cliffort Odets ;
on y voit Elvis dans son dernier rôle ambitieux.

« Lorsqu'Elvis Presley est venu pour la première fois
à Hollywood pour tourner un film, il est venu me voir.
Il avait vingt et un ans et était millionnaire. Il avait vu
James Dean dans La Fureur de vivre et voulait en
savoir plus sur Jimmy. Nous avons parlé cinéma, et il
m'a dit qu'il ne savait pas comment faire pour frapper
l'actrice qui jouerait avec lui. Je lui ai répondu : "Fais
simplement semblant d'écraser une mouche qui
t'agace." Il m'a répondu : "Mais je ne pourrais jamais
porter la main sur une femme !" Je me suis soudain
rendu compte que ce n'était pas un problème de

motivation. Elvis croyait réellement qu'il devait frapper
la fille de la scène !
Il devait aussi se battre contre un autre acteur, m'a-t-il
dit, mais il était en bonne forme physique et pensait
qu'il pourrait facilement en venir à bout. Je lui ai
expliqué qu'on ne frappait jamais les gens pour de vrai
dans les films, que tout était truqué ... Elvis s'est mis en
colère. Il croyait que je me moquais de lui ; il ne
pouvait admettre que tous les films qu'il avait vus
pendant des années étaient truqués. »
Dennis Hopper

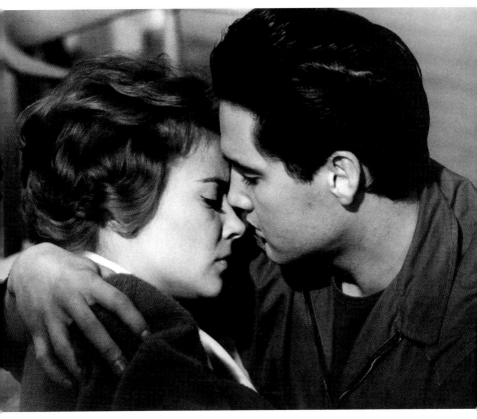

STILL FROM 'WILD IN THE COUNTRY' (1961)
The affair with his social worker (Hope Lange) sparks a
scandal that jeopardizes them both. / Die Affäre mit der
Sozialarbeiterin (Hope Lange) löst einen Skandal aus
und bringt beide in Gefahr. / Son aventure avec son
assistante sociale (Hope Lange) fait éclater un scandale
qui met leur vie en danger.

STILL FROM 'BLUE HAWAII' (1961)
Heir to a thriving pineapple plantation, Elvis is content to make music and work as a tour guide. / Als Erbe einer gut gehenden Ananasplantage gibt sich Chad (Elvis Presley) damit zufrieden, Musik zu machen und Fremdenführer zu spielen. / Héritier d'une prospère plantation d'ananas, Elvis passe agréablement ses journées à jouer de la musique et à travailler comme guide.

STILL FROM 'BLUE HAWAII' (1961)
Fresh out of the army, he upsets his wealthy parents by falling for a native girl (Joan Blackman). / Kurz nach seiner Entlassung aus dem Militärdienst bringt er seine wohlhabenden Eltern dadurch aus der Fassung, dass er sich in eine Einheimische (Joan Blackman) verliebt. / À peine sorti de l'armée, il exaspère ses parents fortunés en s'entichant d'une indigène (Joan Blackman).

PAGES 64/65
POSTER FOR 'BLUE HAWAII' (1961)
The new, indelible Elvis formula: exotic locale, crowds of women, keep the songs coming. / Die neue wind- und wetterfeste Elvis-Formel: exotischer Schauplatz, Scharen von Mädchen und jede Menge Gesang. / La nouvelle formule magique d'Elvis : un décor exotique, une myriades de femmes et des chansons à gogo.

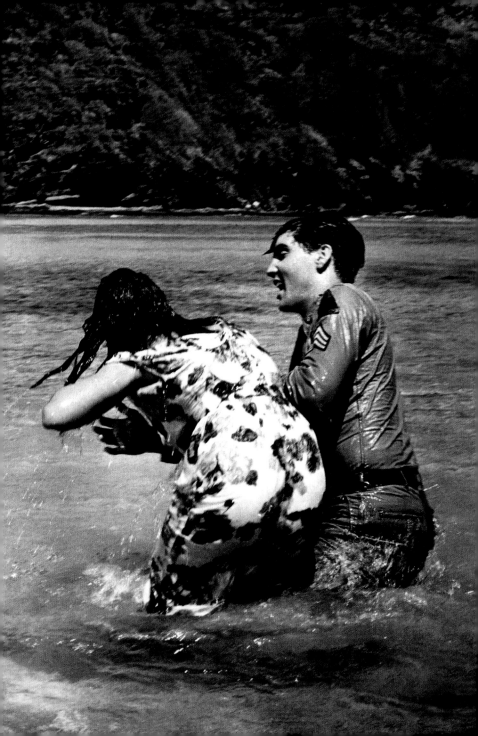

ELVIS PRESLEY

con

JOAN BLACKMAN

ANGELA LANSBURY

Nancy Walters

in Una produzione

HAL WALLIS

Diretto da Norman Taurog
Sceneggiatura di Hal Kanter

TECHNICOLOR e PANAVISION

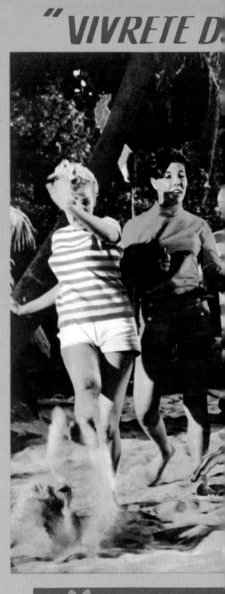

BLU

È un film Paramount · Paramount Films

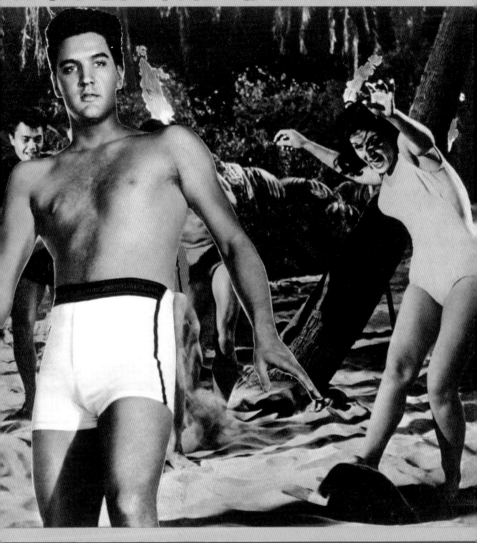

RE IN UN PAESE DI SOGNO"

E *HAWAII

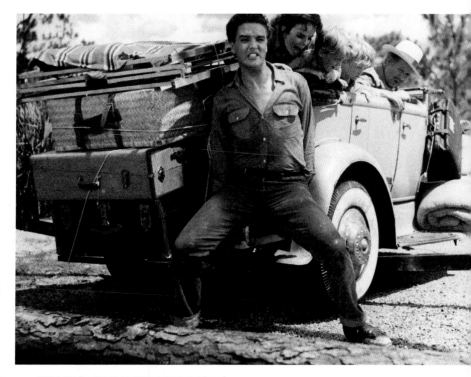

STILL FROM 'FOLLOW THAT DREAM' (1962)
A rustic comedy with farcical overtones. Elvis plays
Toby Kwimper, the eldest child in a clan of bumbling
country-folk. / Bauerntheater mit possenhaften Zügen:
Elvis spielt Toby Kwimper, den ältesten Spross einer
Familie vertrottelter Landeier. / Une comédie rustique
aux allures clownesques. Elvis y joue le rôle de Toby
Kwimper, l'aîné d'un clan de paysans empotés.

**ON THE SET OF 'FOLLOW THAT DREAM'
(1962)**
With co-star Anne Helm as Toby's protective girl, Sweet
Holly Jones. / Anne Helm spielt Sweet Holly Jones, die
Toby beschützt. / Avec sa partenaire Anne Helm dans le
rôle de Sweet Holly Jones, la petite amie protectrice
de Toby.

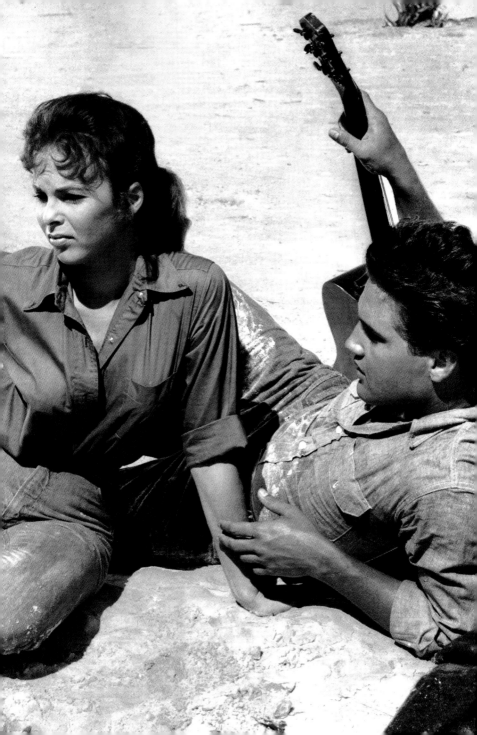

ON THE SET OF 'FOLLOW THAT DREAM' (1962)

Elvis grew up poor, but maintained a sense of humor about hardship. / Elvis wuchs in ärmlichen Verhältnissen auf, aber er behielt seinen Sinn für Humor, wenn es um harte Zeiten ging. / Issu d'un milieu pauvre, Elvis a su garder son sens de l'humour dans l'adversité.

"Just send me a million dollars, never mind the script, and Elvis will do the picture."
Colonel Parker to 20th Century Fox, circa 1965

"I'll keep right on managing him."
Colonel Parker, asked of his plans now that Elvis was dead

„Schickt mir einfach eine Million Dollar, das Drehbuch spielt keine Rolle. Elvis wird den Film machen.“
Colonel Parker zu 20th Century-Fox, um 1965

„Ich manage ihn einfach weiter.“
Colonel Parker auf die Frage, was er nun, da Elvis tot sei, zu tun gedenke

ON THE SET OF 'FOLLOW THAT DREAM' (1962)

His family's goal is to claim 'squatter's rights' on an obscure stretch of highway, and open a bait shop. / Die Familie hat sich zum Ziel gesetzt, ein obskures Stück Straße zu „besetzen", um dort einen Laden für Fischköder zu eröffnen. / L'objectif de sa famille est de faire valoir son « droit d'occupation » au bord d'une sombre autoroute et d'ouvrir une boutique d'appâts pour la pêche.

« Envoyez-moi seulement un million de dollars, peu importe le scénario, Elvis fera l'affaire. »
Le colonel Parker à la 20th Century Fox, vers 1965

« Je vais continuer de gérer sa carrière. »
Le colonel Parker, lorsqu'on l'interroge sur ses projets maintenant qu'Elvis est mort

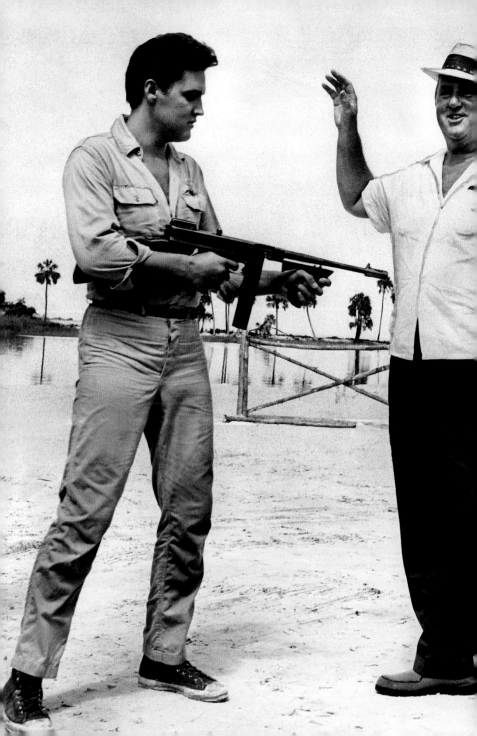

20th Century Fox, making an offer for Love Me
Tender: "Would $25,000 be all right?"
Colonel Parker, Elvis' manager: "That's fine for me.
Now, how about the boy?"

"When I met him, he only had a million dollars
worth of talent. Now he's got a million dollars!"
Colonel Parker

20th Century-Fox, als Angebot für Love Me
Tender [Pulverdampf und heiße Lieder]: „Wären
25.000 Dollar in Ordnung?"
Colonel Parker, Elvis' Manager: „Das wäre für mich
in Ordnung. Und was soll der Junge kriegen?"

„Als ich ihn kennenlernte, hatte er nur für eine
Million Dollar Talent. Jetzt hat er eine Million
Dollar!"
Colonel Parker

La 20th Century Fox fait une offre pour
Le Cavalier du crépuscule : « 25 000 dollars, ça
vous irait ? »
Et le colonel Parker, le manager d'Elvis, de
répondre : « Moi, ça me va. Et combien pour le
gamin ? »

« Quand je l'ai rencontré, son talent valait des
millions. Et maintenant, il a des millions de
dollars ! »
Le colonel Parker

ON THE SET OF 'FOLLOW THAT DREAM'
(1962)
Aiming a toy gun at Colonel Tom Parker, who guided
his career and, sad to say, favored only light musicals. /
Mit einem Spielzeuggewehr zielt Elvis auf Colonel Tom
Parker, der seine Karriere steuerte und leider
anspruchslosen Musicals stets den Vorzug gab. / Elvis
pointe un pistolet en plastique sur le colonel Tom
Parker, qui a guidé sa carrière et a malheureusement
privilégié les comédies musicales frivoles.

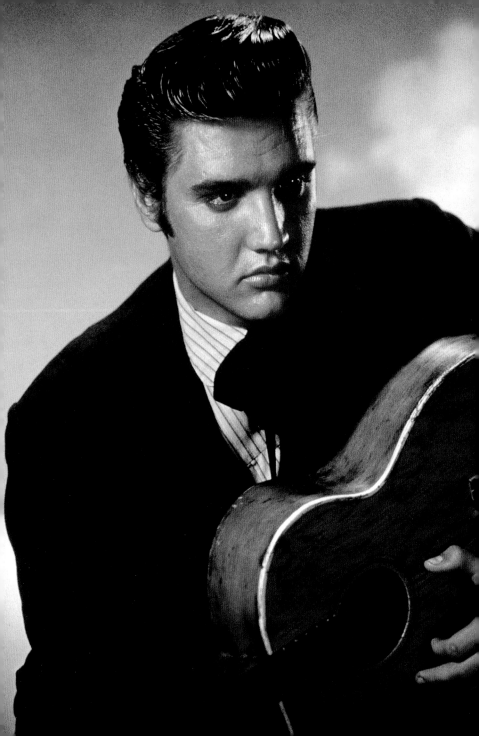

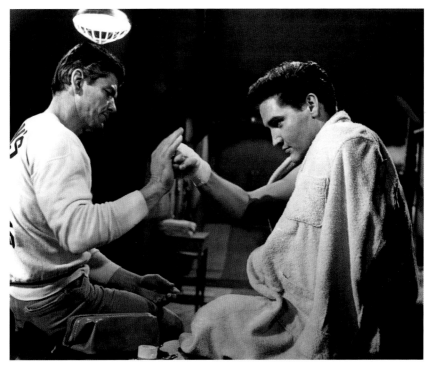

STILL FROM 'KID GALAHAD' (1962)
With Charles Bronson (left), as his trainer. / Mit Charles
Bronson (links), der seinen Trainer spielt. / Avec Charles
Bronson (à gauche), dans la peau de son entraîneur.

PORTRAIT FOR 'KID GALAHAD' (1962)
Despite the predominance of light-hearted musical
elements, Elvis took this role seriously. / Obwohl die
eher heiteren musikalischen Einlagen den Film
beherrschten, nahm Elvis seine Rolle ernst. / Malgré la
prédominance de chansonnettes dans ce film, Elvis
prend son rôle au sérieux.

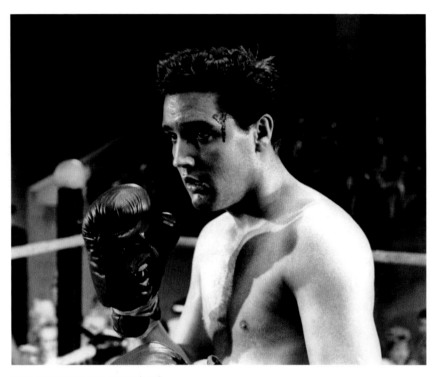

STILL FROM 'KID GALAHAD' (1962)
Elvis trained diligently for this part, keeping to an
intensive schedule of running and exercise. / Elvis
unterzog sich für seine Rolle einem umfangreichen
Intensivtraining, das aus Laufen und anderen Übungen
bestand. / Elvis s'est entraîné avec assiduité pour ce
rôle, respectant un programme intensif de course à
pied et d'exercices physiques.

PORTRAIT FOR 'KID GALAHAD' (1962)
Striking a pose, and an opponent. / Eine Pose fürs
Werbefoto — und ein Haken, der sitzt. / Elvis prend la
pose et envoie son adversaire au tapis.

PAGES 76/77
PORTRAIT FOR 'GIRLS! GIRLS! GIRLS!' (1962)
A classic pose in Elvisland — the object of adoring
attention. / Eine klassische Pose in Elvisland: bewundert
und angehimmelt. / Un grand classique au royaume
d'Elvis: une pose qui suscite l'adulation de la gent
féminine.

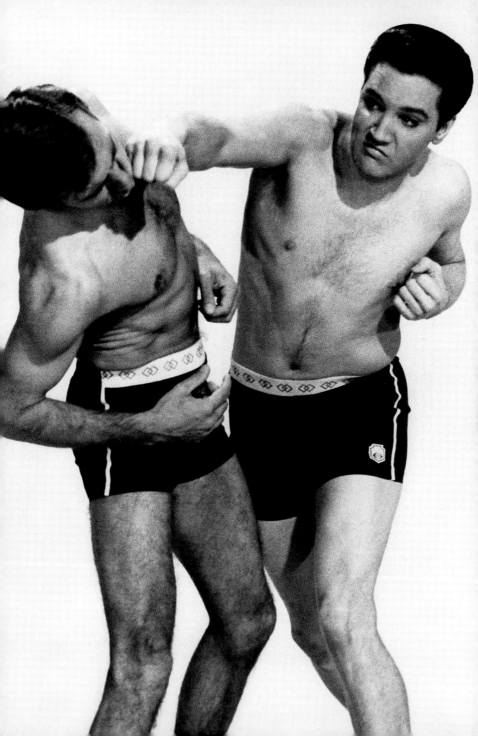

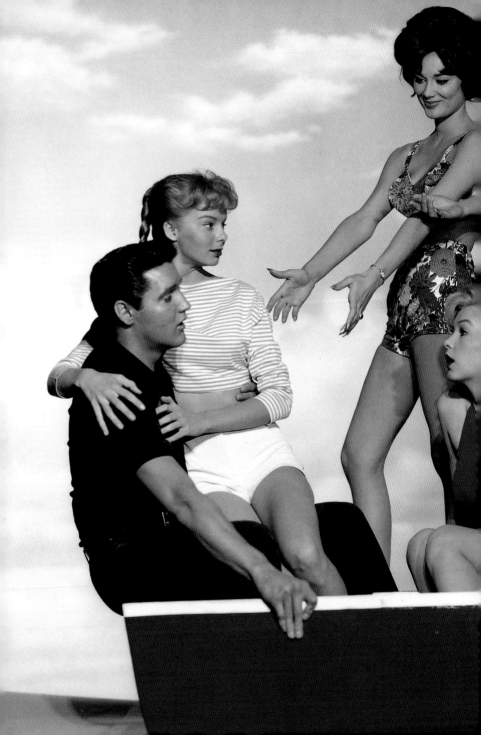

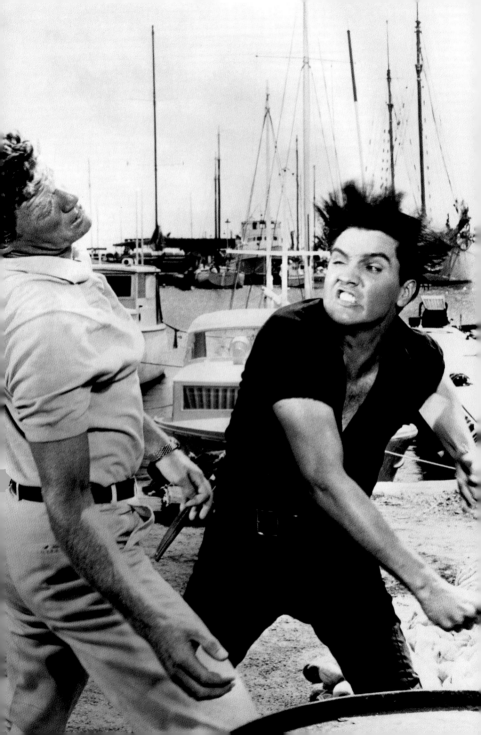

STILL FROM 'GIRLS! GIRLS! GIRLS!' (1962)
Elvis plays a charter-boat fisherman who works nights
as — what else — a nightclub singer. / Elvis spielt in
diesem Film einen Fischer mit einem Charterboot,
der nebenbei noch — was sonst? — als Sänger in einem
Nachtclub jobbt. / Elvis incarne un marin pêcheur qui
travaille la nuit comme ... chanteur de boîte de nuit.

STILL FROM 'GIRLS! GIRLS! GIRLS!' (1962)
Elvis, grimacing like Popeye the Sailor, is more
convincing throwing a punch than is the fellow taking
it. / Elvis wirkt trotz Popeye-Grimasse überzeugender
als sein „Opfer". / Grimaçant comme Popeye le marin,
Elvis convainc plus en assénant un bon coup de poing
que son rival en l'encaissant.

STILL FROM 'GIRLS! GIRLS! GIRLS!' (1962)
Stella Stevens, later a star in her own right, is the sexy
'bad girl' of the many pursuing him. / Stella Stevens, die
später selbst zum Star wurde, ist das erotische „böse
Mädchen" unter all jenen, die Ross (Elvis Presley)
nachlaufen. / Stella Stevens, qui deviendra plus tard une
grande star, tient le rôle de la « bad girl » sexy parmi
toutes les femmes qui le poursuivent.

*"A Presley picture is the one sure thing in
Hollywood."*
Hal B. Wallis, who produced most of them

*„Ein Presley-Film ist die einzige todsichere Sache
in Hollywood."*
Hal B. Wallis, der die meisten von ihnen produzierte

*« Un film d'Elvis, il n'y a que ça de vrai à
Hollywood. »*
Hal B. Wallis, qui a produit la plupart de ses films

STILL FROM 'GIRLS! GIRLS! GIRLS!' (1962)
Many actors dread being upstaged by cute children. Not so for Elvis. / Vielen Schauspielern graut bei dem Gedanken, süße kleine Kinder könnten ihnen die Show stehlen, aber Elvis machte das nichts aus. / Beaucoup d'acteurs ont horreur de se faire voler la vedette par de charmants bambins. Ce n'est pas le cas d'Elvis.

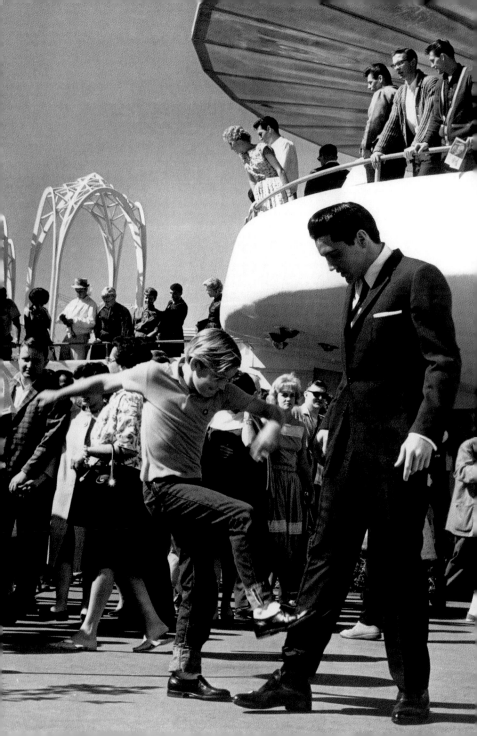

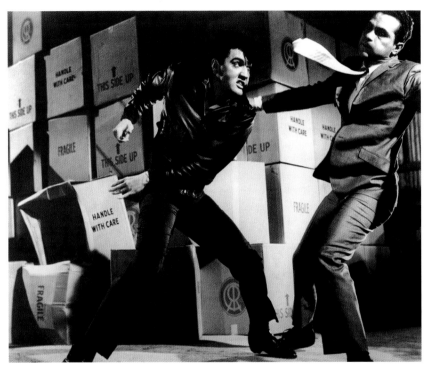

STILL FROM 'IT HAPPENED AT THE WORLD'S FAIR' (1963)
Elvis works the Seattle World's Fair to pay off a debt. A pal embroils him with smugglers. / Mike (Elvis Presley) arbeitet bei der Weltausstellung in Seattle, um Spielschulden zurückzuzahlen. / Elvis travaille à l'Exposition universelle de Seattle pour rembourser une dette. Un type le mêle à une bande de trafiquants.

STILL FROM 'IT HAPPENED AT THE WORLD'S FAIR' (1963)
Receiving a stomping by a very young Kurt Russell, who would go on to star in an acclaimed Elvis biopic. / Der Junge, der Elvis hier auf den Fuß stampft, ist Kurt Russell, der in einer vielgelobten Filmbiographie später einmal selbst Elvis spielte. / Elvis se fait écraser le pied par le très jeune Kurt Russell, qui réapparaîtra dans un film plébiscité sur la vie du King.

STILL FROM 'IT HAPPENED AT THE WORLD'S FAIR' (1963)
Amid other adventures, Elvis protects a cute child played by Vicky Tiu, who had been a hit in 'Girls! Girls! Girls!' / Neben anderen Abenteuern, die Mike (Elvis Presley) erlebt, beschützt er auch noch ein kleines Mädchen, gespielt von Vicky Tiu, die bereits in *Girls! Girls! Girls!* ein Riesenerfolg war. / Au cœur de ses aventures, Elvis protège une jolie jeune fille jouée par Vicky Tiu, qui avait fait un carton dans *Des filles, encore des filles!*

"When I came out they wasn't playing no black artists on no Top 40 stations — but ... I thank the Lord for sending Elvis to open that door so I could walk down the road, you understand?"
Little Richard

„Als ich rauskam, da haben die keine schwarzen Künstler bei Top-40-Sendern aufgelegt, aber ... ich danke dem Herrn, dass er Elvis geschickt hat, um diese Tür zu öffnen, damit ich diesen Weg gehen konnte, verstehst du?"
Little Richard

« Quand je suis arrivé, on n'entendait aucun artiste noir dans les hit-parades mais ... je remercie le ciel de nous avoir envoyé Elvis. Il a ouvert une voie dans laquelle j'ai pu m'engouffrer, vous comprenez ? »
Little Richard

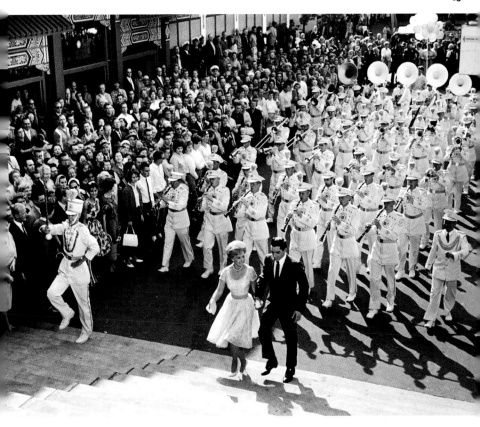

STILL FROM 'IT HAPPENED AT THE WORLD'S FAIR' (1963)
When Elvis goes a-courtin' (here, with Joan O'Brien) the fates comply with a marching band. / Wenn Elvis auf Freiersfüßen wandelt (hier mit Filmpartnerin Joan O'Brien), dann ist wie durch Zufall auch immer gleich eine Marschkapelle zur Stelle. / Lorsqu'Elvis fait la cour à une demoiselle (ici, à Joan O'Brien), une fanfare apparaît comme par enchantement.

PAGES 86/87
ON THE SET OF 'IT HAPPENED AT THE WORLD'S FAIR' (1963)
The old catchphrase, "Elvis has left the building" addresses this very kind of mass public adoration. / Der Ursprung des bekannten Spruchs „Elvis hat das Gebäude verlassen" liegt in genau dieser Art von Massenhysterie. / La vieille réplique « Elvis has left the building » (« Désolé mais Elvis est déjà parti ») s'adresse très exactement à ce genre de public en émoi.

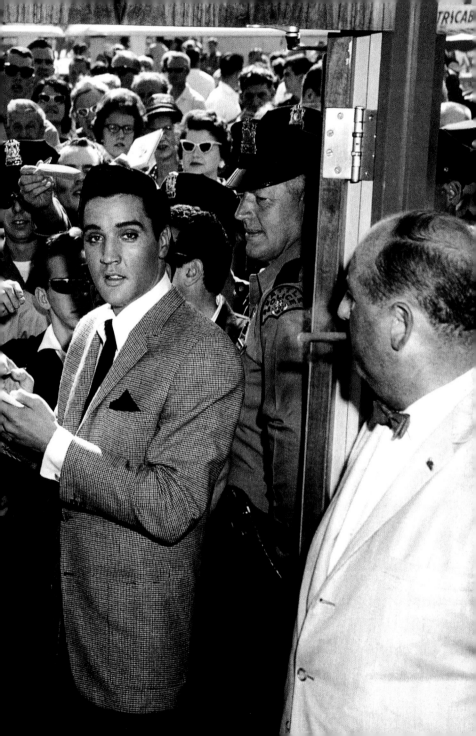

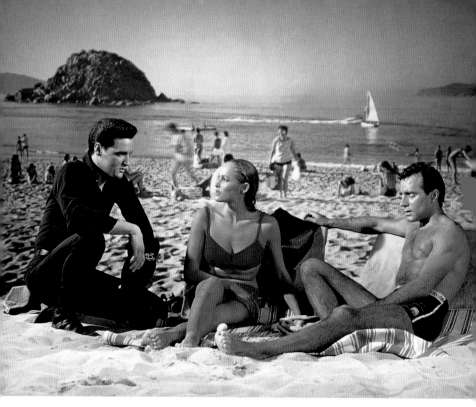

STILL FROM 'FUN IN ACAPULCO' (1963)
Pursuing a great beauty (Ursula Andress) at a tropic
resort hotel, but opposed by her high-diving lover. /
In einer Ferienanlage in den Tropen hat es Mike (Elvis
Presley) auf eine blonde Schönheit (Ursula Andress)
abgesehen, aber deren sportlicher Freund ist damit gar
nicht einverstanden. / À la poursuite d'une femme
splendide (Ursula Andress) dans un grand hôtel des
Tropiques, il se retrouve nez à nez avec son amant à la
carrure d'athlète.

*"I don't believe in Stanislavski or whatever those
methods of acting are called. I have never read
Stanislavski and I don't intend to. I don't believe in
drama teachers either. Why should I? The director
I work with is my teacher for the time being and
anything he tells me goes."*
Elvis Presley

*„Ich glaube nicht an Stanislavski oder wie man
diese Schauspielmethoden auch nennt. Ich habe
Stanislavski nie gelesen und habe auch nicht
die Absicht. Ich glaube auch nicht an Schauspiel-
unterricht. Warum sollte ich? Der Regisseur, mit
dem ich arbeite, ist für die Dauer der Dreharbeiten
mein Lehrer, und was er sagt, wird gemacht."*
Elvis Presley

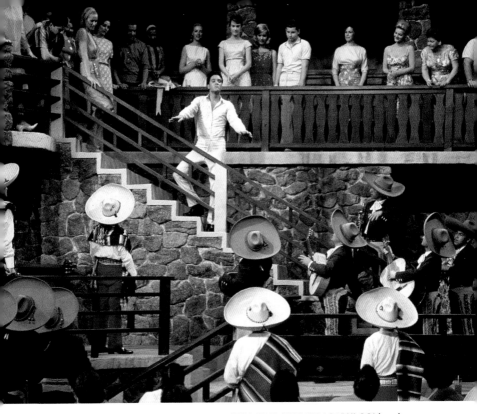

STILL FROM 'FUN IN ACAPULCO' (1963)
Playing a former trapeze artist, guilty after a partner is
injured, Elvis takes work as a singing lifeguard. It often
happens. / Elvis spielt hier — ganz aus dem Leben
gegriffen — einen ehemaligen Trapezkünstler, der sich
nach einem Unfall seines Partners schuldig fühlt und
daraufhin einen Job als singender Rettungsschwimmer
in Mexiko annimmt. / Dans la peau d'un ancien
trapéziste qui se sent coupable de la blessure de son
partenaire, Elvis accepte un boulot de sauveteur-
chanteur. Des choses qui arrivent.

*« Je ne crois pas à Stanislavski [le père de la
"Méthode"] ou à une quelconque méthode pour
apprendre à jouer la comédie. Je n'ai jamais ouvert
un de ces fichus livres et je n'ai pas l'intention de le
faire. Je ne crois pas non plus aux professeurs de
théâtre. Pourquoi est-ce que je devrais y croire ?
Le réalisateur avec lequel je travaille est mon
professeur en ce moment : je fais tout ce qu'il me
dit de faire. »*
Elvis Presley

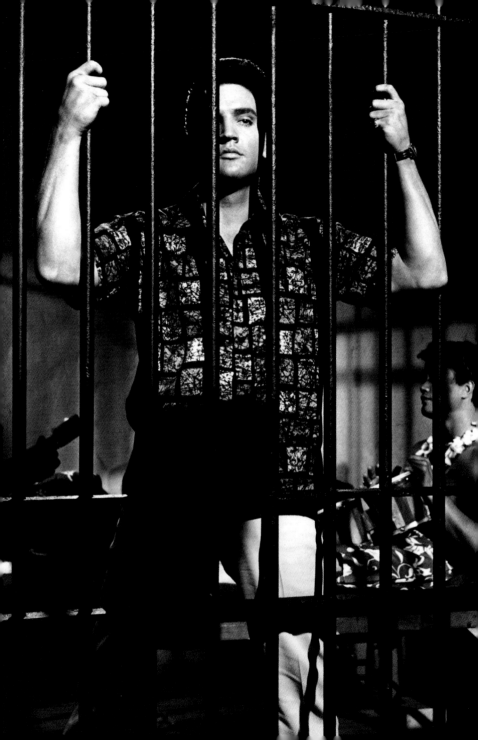

STILL FROM 'FUN IN ACAPULCO' (1963)
Did somebody say, a big musical number in a flamboyant costume? Did somebody say, Las Vegas? / Hat irgendjemand nach einer großen Musiknummer mit extravaganten Kostümen gefragt? Wollte irgendjemand Las Vegas sehen? / Qui a demandé un grand show musical dans un costume flamboyant? Qui a demandé Las Vegas?

STILL FROM 'FUN IN ACAPULCO' (1963)
What Elvis comedy would be complete without a quick stretch behind bars? / Eine Komödie mit Elvis wäre nicht vollständig, wenn er nicht auch einmal kurz hinter Gitter müsste. / Quelle comédie d'Elvis serait complète sans un petit passage derrière les barreaux?

STILL FROM 'KISSIN' COUSINS' (1964)
Country boy Jodie (the blonde Elvis on the ground)
confronts a beauty from the Air Force (Pam Austin). /
Landei Jodie (der blonde Elvis am Boden) mit einer
Schönheit von der Luftwaffe (Pam Austin). / Jodie,
un gars de la campagne (Elvis en blond, au sol), face
à une beauté de l'armée de l'air (Pam Austin).

"I've been scratched and bitten. Girls would throw
their handkerchiefs at me, and I'd blow my nose on
'em and toss 'em right back and them ladies would
hug those hankies to their breasts and never wash
'em. I just accept it with a broad mind."
Elvis Presley

„Ich wurde schon gekratzt und gebissen.
Mädchen haben mir Taschentücher zugeworfen,
und ich hab hineingeschnäuzt und sie ihnen
zurückgeworfen, und diese jungen Damen haben
diese Taschentücher an die Brust gedrückt und nie
wieder gewaschen. Ich bin aufgeschlossen und
nehme das einfach so hin."
Elvis Presley

STILL FROM 'KISSIN' COUSINS' (1964)
Air Force man Josh (the black-haired Elvis, with Yvonne
Craig) wants to buy land for a missile silo. / Josh
(der schwarzhaarige Elvis, hier mit Yvonne Craig) ist
bei der Luftwaffe und soll Land aufkaufen, um dort ein
Raketensilo zu bauen. / Un type de l'armée de l'air, Josh
(l'Elvis aux cheveux noirs, avec Yvonne Craig), veut
acheter un terrain pour un silo de missiles.

*« On m'a griffé et mordu. Les filles me jetaient
leurs mouchoirs ; je me mouchais avec et leur
rendais. Elles serraient leur mouchoir contre leur
cœur et décidaient de ne plus jamais le laver.
Je peux accepter ça, je suis ouvert d'esprit. »*
Elvis Presley

PAGES 94/95
STILL FROM 'KISSIN' COUSINS' (1964)
After a tangle of romantic misunderstandings, the two
Elvises sing and dance together in triumph. / Nach
einigen romantischen Irrungen und Wirrungen singen
die beiden Elvisse triumphierend im Duett. / Après un
quiproquo amoureux, les deux Elvis se lancent dans un
duo et remportent un franc succès.

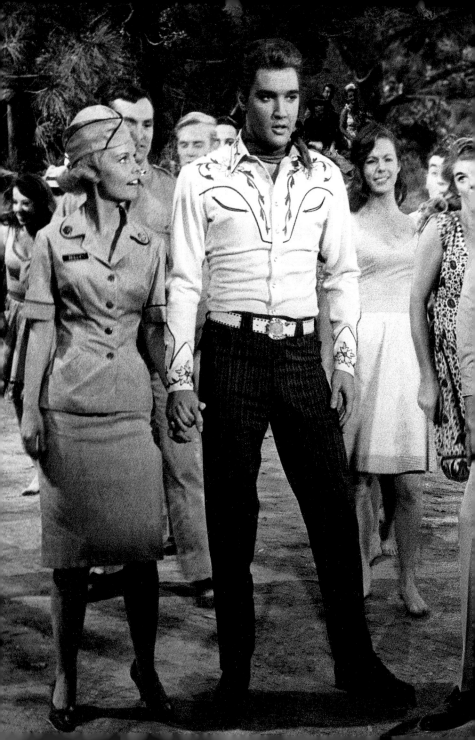

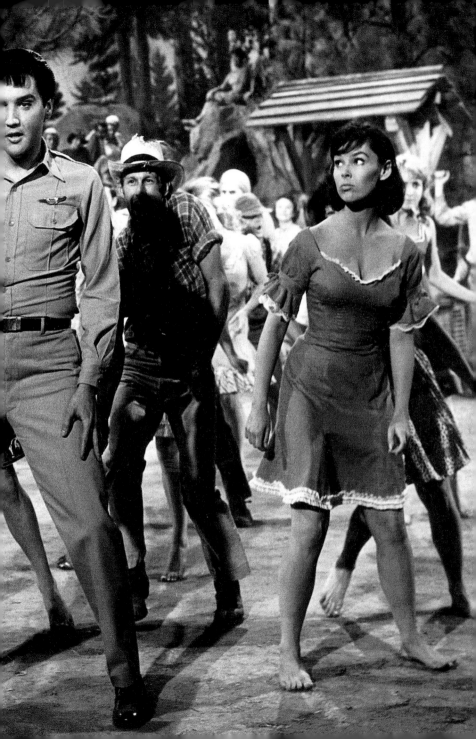

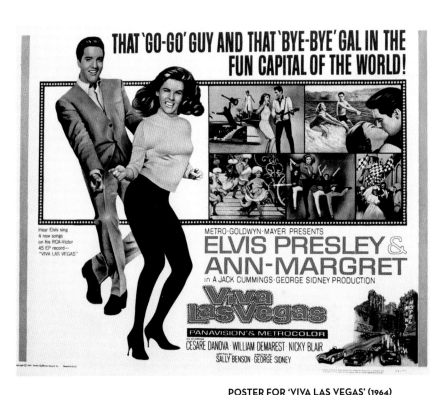

POSTER FOR 'VIVA LAS VEGAS' (1964)
Elvis connoisseurs generally consider this the best of his musical comedies, perhaps his best film overall. / Elvis-Kenner halten dies allgemein für die beste seiner musikalischen Komödien, möglicherweise sogar für seinen besten Film überhaupt. / Les connaisseurs d'Elvis considèrent généralement ce film comme sa meilleure comédie musicale, peut-être même le meilleur film de sa carrière.

STILL FROM 'VIVA LAS VEGAS' (1964)
Later, Las Vegas would be his professional home. For now, it is just another locale for an onscreen romp. / Später ließ sich Elvis beruflich in Las Vegas nieder, aber zu dieser Zeit war es nur ein weiterer Schauplatz für seinen Leinwandklamauk. / Plus tard, il installera ses quartiers à Las Vegas. Pour l'instant, ce n'est qu'un décor de plus pour ses films « légers ».

PAGES 98 & 99
STILLS FROM 'VIVA LAS VEGAS' (1964)
The press dubbed Swedish-born Ann-Margret "The Female Elvis" long before they met. / In der Presse wurde die gebürtige Schwedin Ann-Margret, schon lange bevor sie ihn kennenlernte, als „weiblicher Elvis" bezeichnet. / Bien avant leur rencontre, la presse surnomme la Suédoise Ann-Margret l'« Elvis en jupon ».

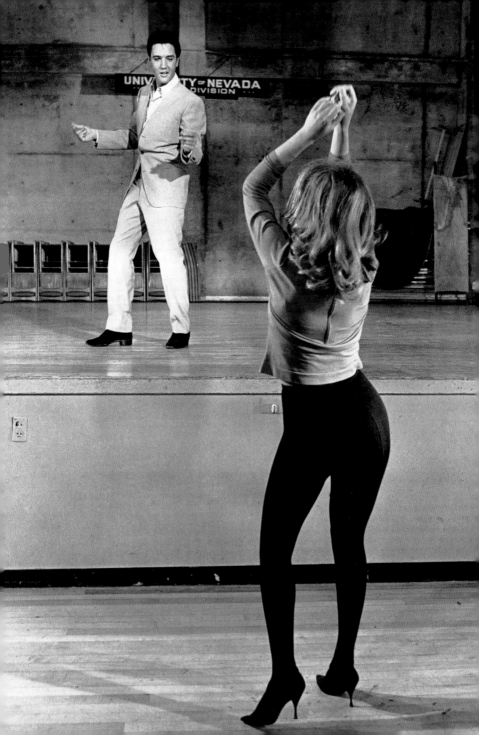

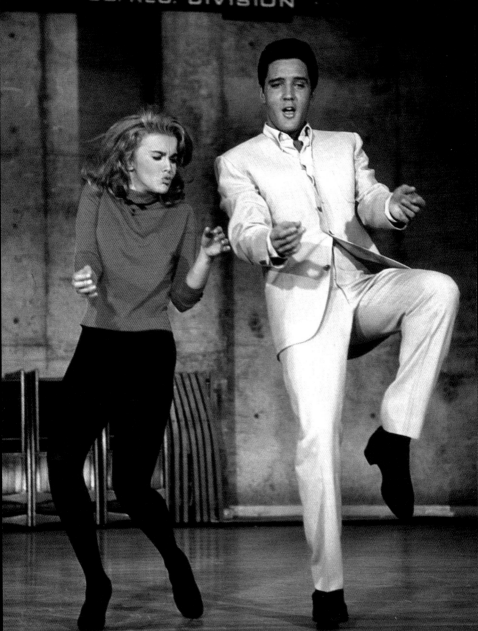

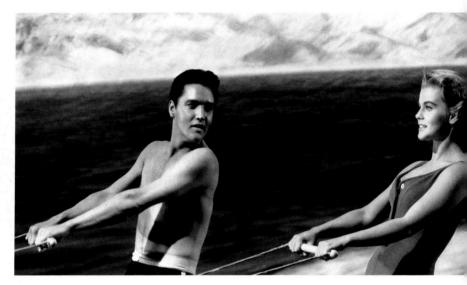

STILL FROM 'VIVA LAS VEGAS' (1964)
Skiing on a rear-projected lake, every hair still in place. /
Wasserski vor einer Rückprojektion – so gerät auch die
Frisur nicht durcheinander. / Elvis fait du ski nautique
sur un lac qui défile en arrière-plan. Pas une mèche de
travers.

ON THE SET OF 'VIVA LAS VEGAS' (1964)
Same beautiful bone structure, same big hair, same
smiles: romance was inevitable. / Der gleiche hübsche
Knochenbau, die gleiche große Frisur, das gleiche
Lächeln: da war die Romanze unvermeidlich. / Mêmes
pommettes, même brushing, même sourire : comment
échapper à la romance ?

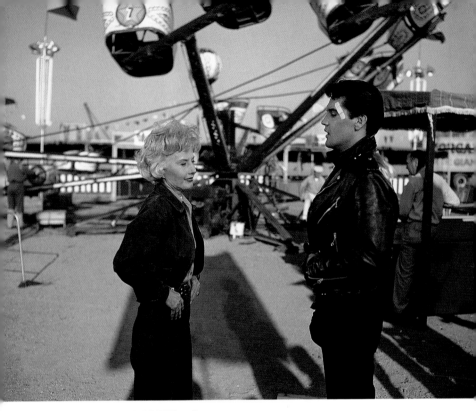

STILL FROM 'ROUSTABOUT' (1964)
Elvis had long admired costar Barbara Stanwyck, who helped him sharpen his acting skills. / Elvis bewunderte schon seit langem seine Filmpartnerin Barbara Stanwyck, die ihm half, sein schauspielerisches Talent weiter zu verfeinern. / Elvis admire depuis longtemps sa partenaire Barbara Stanwyck, qui l'a aidé à peaufiner ses talents d'acteur.

"I've been blamed for just about everything wrong in this country. Juvenile delinquency, that I give kids 'ideas,' that I'm 'vulgar.' I wouldn't do anything vulgar in front of anybody. My folks didn't bring me up that way."
Elvis Presley

„Man hat mir die Schuld an ziemlich allem gegeben, was in diesem Land nicht stimmt: Jugendkriminalität, dass ich die Kinder auf ‚dumme Gedanken' brächte, dass ich ‚vulgär' sei. Ich würde vor niemandem etwas Vulgäres tun. So haben mich meine Eltern nicht erzogen."
Elvis Presley

STILL FROM 'ROUSTABOUT' (1964)
"Roustabouts" are handymen who travel with carnivals.
The job has its benefits. / „Roustabouts" sind
Hilfsarbeiter, die mit Jahrmärkten durchs Land ziehen.
Der Job hat auch Vorteile. / Les « roustabouts » sont des
hommes à tout faire qui accompagnent les fêtes
foraines. Un boulot qui a ses avantages.

« On m'a reproché tout ce qui va mal dans le pays.
D'être responsable de la délinquance juvénile,
d'avoir "mis des idées dans la tête des gamins",
d'être "vulgaire". Je ne fais jamais quoi que ce soit
de vulgaire devant qui que ce soit. Ce n'est pas le
genre d'éducation que mes parents m'ont donnée. »
Elvis Presley

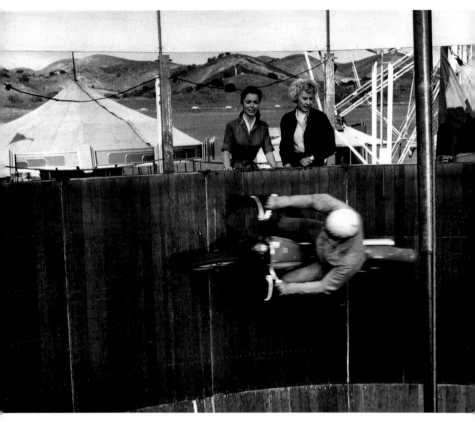

STILL FROM 'ROUSTABOUT' (1964)
Joan Freeman (left) and Barbara Stanwyck (right) watch
Elvis defy gravity. / Joan Freeman (links) und Barbara
Stanwyck (rechts) schauen zu, wie Charlie (Elvis
Presley) der Schwerkraft ein Schnippchen schlägt. /
Joan Freeman (à gauche) et Barbara Stanwyck (à droite)
observent Elvis en train de défier les lois de la gravité.

"Elvis came to my Deer Lake training camp.
He told me he didn't want nobody to bother us,
he wanted peace and quiet. I don't admire nobody,
but Elvis Presley was the sweetest, most humble
and nicest man you'd ever meet."
Muhammad Ali

„Elvis kam in mein Trainingslager am Deer Lake.
Er sagte mir, er wolle von niemandem gestört
werden, er wolle Ruhe und Frieden. Ich bewundere
niemanden, aber Elvis Presley war der netteste,
bescheidenste und liebenswürdigste Mensch, den
ich jemals kennengelernt habe."
Muhammad Ali

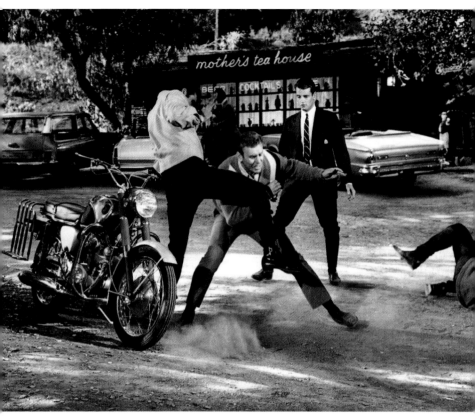

STILL FROM 'ROUSTABOUT' (1964)
Hostile machos attack. Note the tavern's ironic name. /
Feindselige Machos greifen an! Man beachte den
ironischen Namen der Kneipe („Mutters Teehaus"). /
Une bande de machos agressifs passent à l'attaque. On
notera le nom ironique de la taverne.

« Elvis est venu à mon camp d'entraînement de
Deer Lake. Il m'a dit qu'il ne voulait pas qu'on nous
ennuie, il voulait juste être tranquille. Je ne dis pas
que je l'admire, mais Elvis était l'homme le plus
gentil, le plus humble et le plus doux que j'aie
jamais rencontré. »
Mohammed Ali

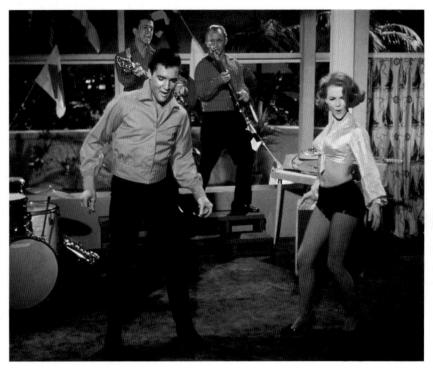

STILL FROM 'GIRL HAPPY' (1965)
Singing and shimmying with Shelly Fabares (right), his
favorite among leading ladies. / Hier singt und tanzt
er mit Shelley Fabares (rechts), seiner bevorzugten
Filmpartnerin. / En duo avec Shelly Fabares (à droite),
sa partenaire préférée.

STILL FROM 'GIRL HAPPY' (1965)
A baptism of beer as he navigates a resort overrun with
drunken college students. / Als er versucht, sich seinen
Weg durch eine Ferienanlage zu bahnen, die von
betrunkenen Studenten bevölkert ist, bleibt eine Bier-
dusche nicht aus. / Elvis est baptisé à la bière en se
frayant un chemin dans une station estivale envahie par
une horde d'étudiants ivres.

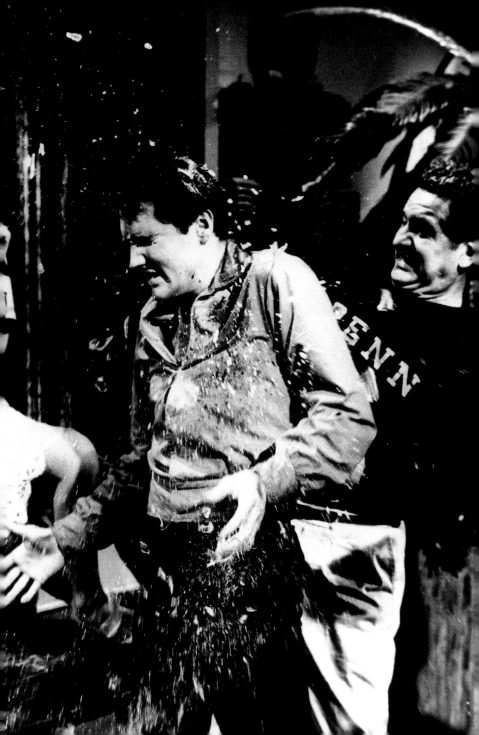

STILL FROM 'GIRL HAPPY' (1965)
The setting is Florida, during the legendary annual
bacchanal called "Spring Break." / Der Film spielt in
Florida während der alljährlichen Saufgelage, die sich
„Spring Break" (Semesterferien im Frühjahr) nennen. /
L'histoire se passe en Floride, lors de la légendaire
bacchanale annuelle des « vacances de printemps ».

"I never took any singing lessons, and the only
practicing I ever did was on a broomstick before
my Dad bought me my first guitar."
Elvis Presley

„Ich nahm nie Gesangsunterricht, und geübt hab
ich nur auf einem Besenstiel, bevor mir mein Dad
die erste Gitarre kaufte."
Elvis Presley

« Je n'ai jamais pris de cours de chant, et le seul
entraînement que j'ai suivi, c'était avec un manche
à balai, avant que mon père m'achète ma première
guitare. »
Elvis Presley

STILL FROM 'GIRL HAPPY' (1965)
Elvis has been sent to Florida to keep an eye on his
boss' daughter (Shelly Fabares, right). / Rusty (Elvis
Presley) ist von seinem Chef nach Florida geschickt
worden, um dessen Tochter (Shelly Fabares, rechts)
ein wenig im Auge zu behalten. / Elvis a été envoyé en
Floride pour garder un œil sur la fille de son patron
(Shelly Fabares, à droite).

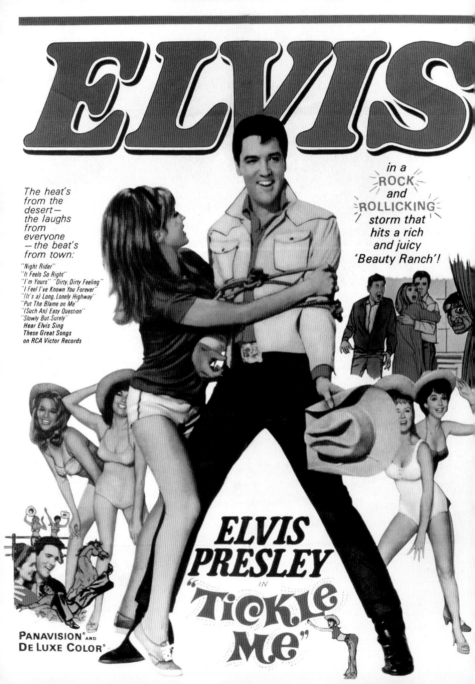

STILL FROM 'TICKLE ME' (1965)
Jocelyn Lane (left) hunts for the Arizona ghost town where her late grandpa buried his gold. / Jocelyn Lane (links) sucht eine Geisterstadt in Arizona, wo ihr verstorbener Großvater einen Goldschatz versteckt hat. / Jocelyn Lane (à gauche) recherche la ville fantôme de l'Arizona où feu son grand-père a enterré son or.

PAGES 112/113
POSTER FOR 'TICKLE ME' (1965)
Elvis plays, yes, a singing rodeo cowboy who moonlights as a handyman at a beauty spa. / Elvis spielt — man glaubt es kaum — einen singenden Rodeocowboy, der nebenbei als Aushilfe auf einer Schönheitsfarm jobbt. / Elvis joue le rôle d'un cow-boy de rodéo qui chante et travaille au noir comme homme à tout faire dans un institut de beauté.

POSTER FOR 'TICKLE ME' (1965)
At three films per year, it was only locigal the titles were in fine print compared to 'ELVIS.' / Bei drei Filmen pro Jahr verstand es sich von selbst, dass der Filmtitel im Kleingedruckten zu finden war — im Gegensatz zu „ELVIS". / Avec une cadence de trois films par an, il est logique que le titre apparaisse en petits caractères à côté d'« ELVIS ».

ELVIS PRE
PER UN PUGNO
E CON **JULIE ADAMS** · **JOCELYN LANE** · **JACK MULL**

IN **PANAVISION** A **DELUX CO**

Sceneggiatura di **ELWOOD ULLMAN** ● **EDWARD BERNDS** Prodotto da **BEN SCHWALB** Regia di **NO**

EY IN

I DONNE

MERRY ANDERS • BILL WILLIAMS

G Una Distribuzione **COLUMBIA PICTURES**

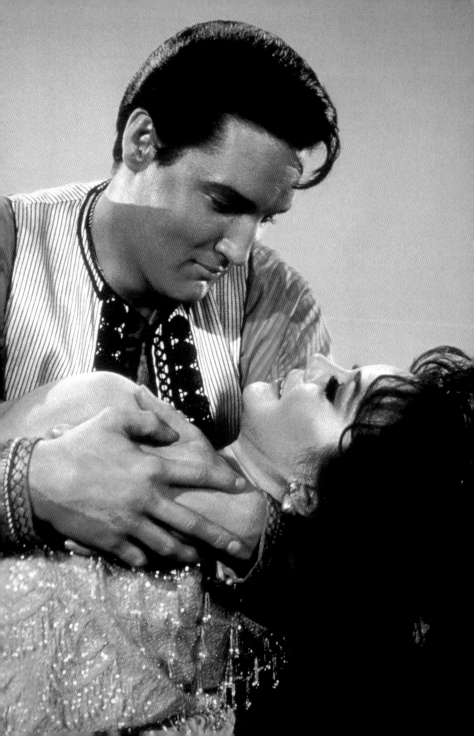

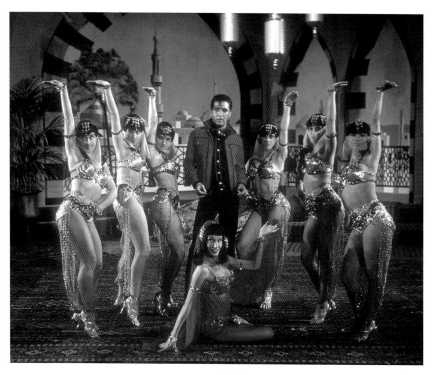

PORTRAIT FOR 'HARUM SCARUM' (1965)
His 'Arabian Nights' adventure adds new luster to the hero's act, once matters are put right. / Sein Abenteuer in „Tausendundeiner Nacht" verleiht seiner Nummer einen ganz neuen Glanz, nachdem erst mal Ordnung geschaffen wurde. / Auréolé de ses aventures à l'écran dans *Mille et Une Nuits*, le héros donne un nouvel éclat à son numéro de scène.

PORTRAIT FOR 'HARUM SCARUM' (1965)
A matinee idol kidnapped by Middle Eastern assassins saves a princess (Mary Ann Mobley). / Ein Jugendidol wird von orientalischen Meuchelmördern entführt und rettet eine Prinzessin (Mary Ann Mobley). / Un acteur idolâtré par la gent féminine est kidnappé par des assassins du Moyen-Orient et sauve une princesse (Mary Ann Mobley).

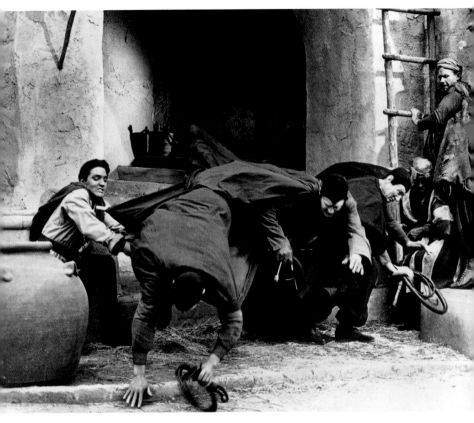

STILL FROM 'HARUM SCARUM' (1965)
Escaping his kidnappers through a bazaar, falling in with good-hearted thieves and pickpockets. / Er entkommt seinen Kidnappern im Basar, wo er hilfsbereite Räuber und Taschendiebe trifft. / Parvenant à semer ses kidnappeurs dans un bazar, il rencontre des voleurs et des pickpockets au cœur tendre.

"There have been a lot of rumors about me, to the point where I think I've got more rumors out there than I do records."
Elvis Presley

„Es hat sehr viele Gerüchte über mich gegeben. Das ging so weit, dass ich schon dachte, ich hätte mehr Gerüchte veranlasst als Schallplatten produziert."
Elvis Presley

« On a proféré un tas de rumeurs à mon sujet, au point qu'il doit exister plus de rumeurs sur mon compte que de chansons de moi. »
Elvis Presley

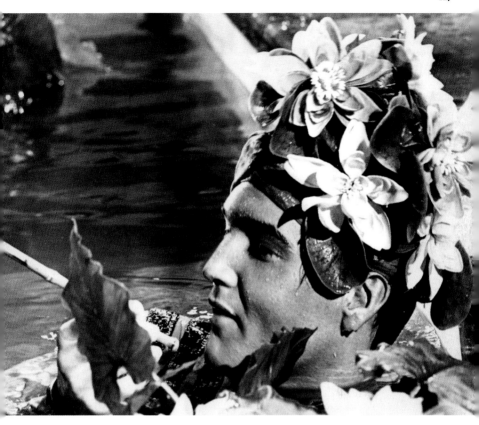

STILL FROM 'HARUM SCARUM' (1965)
Crowned in lilies, but is the smile sincere? Elvis spoke
dismissively of his "Elvis Travelogues." / Er mag zwar
von Lilien gekrönt sein — aber ist sein Lächeln echt?
Elvis sprach immer etwas herablassend von den „Elvis-
Reiseberichten". / Couronné de lys, ce sourire est-il
vraiment sincère ? Elvis parle avec dédain de ses « récits
de voyage ».

PAGES 118/119
STILL FROM 'HARUM SCARUM' (1965)
Either this is trick photography, or that is a heavily
tranquilized leopard. / Entweder handelt es sich hier
um einen Filmtrick oder um einen Leoparden mit einer
hohen Dosis Beruhigungsmittel. / Soit la photo est
truquée, soit ce léopard a reçu une dose carabinée de
tranquillisants.

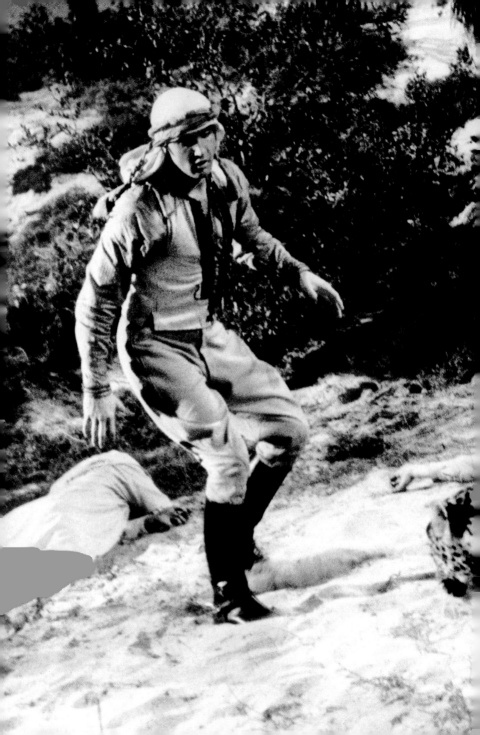

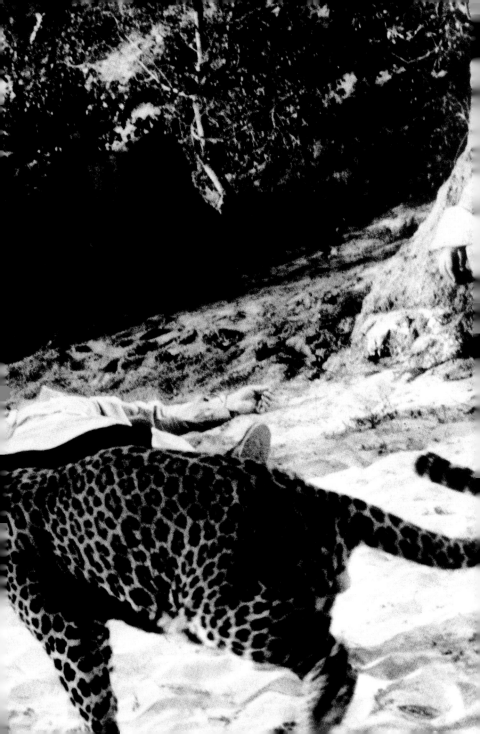

STILL FROM 'FRANKIE AND JOHNNY' (1966)
The classic folk song about doomed lovers gets an
upbeat twist in this version. / Das klassische Volkslied
von der zum Scheitern verurteilten Liebesbeziehung
wird in dieser Version ein wenig aufgeheitert. / Dans
cette version, la chanson folk classique sur les amants
malchanceux prend un tour plus enjoué.

*"As long as there's a public, as long as you're
pleasing people, it'd be foolish to quit."*
Elvis Presley

*„So lange es ein Publikum gibt, so lange ich den
Leuten gefalle, wäre es doch dumm von mir,
aufzuhören."*
Elvis Presley

*« Tant qu'il y a un public, tant qu'on fait plaisir aux
gens, ce serait de la folie d'arrêter. »*
Elvis Presley

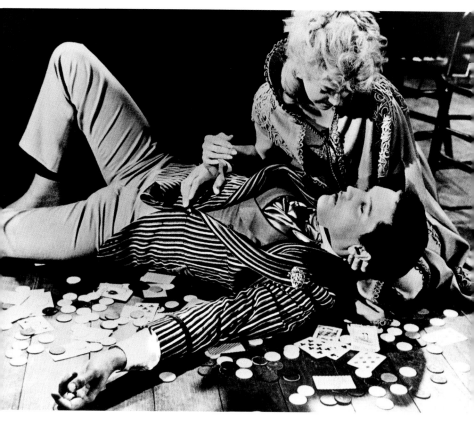

STILL FROM 'FRANKIE AND JOHNNY' (1966)
Elvis and Donna Douglas perform the tragic song, only
to live it out comically in life. / Elvis und Donna Douglas
singen zwar das tragische Lied, aber im „Leben" geben
sie ihm eine komische Wendung. / Elvis et Donna
Douglas reprennent cette chanson bouleversante et lui
donnent une dimension comique.

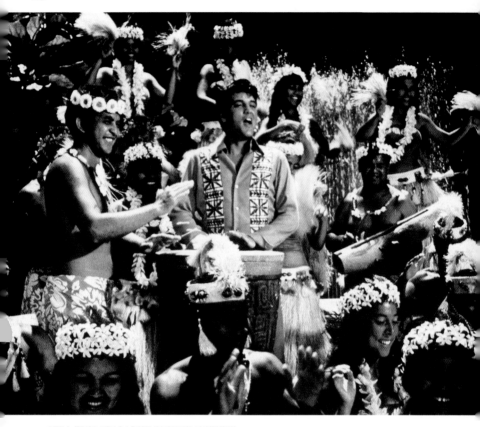

STILL FROM 'PARADISE, HAWAIIAN STYLE'
(1966)
At home anywhere there was music: This was the third
film Elvis made in Hawaii. / Überall, wo Musik war, fühlte
er sich zu Hause: dies war schon der dritte Film, den
Elvis in Hawaii drehte. / Partout où il va, il est chez lui et
la musique l'accompagne : c'est le troisième film qu'Elvis
tourne à Hawaï.

"I learned a lot about people in the army. I never
lived with other people before, and had a chance
to find out how they think. It sure changed me, but
I can't tell you offhand, how."
Elvis Presley

„Ich habe in der Armee eine Menge über die
Menschen gelernt. Ich hatte zuvor nie mit anderen
Menschen zusammengelebt und keine Möglichkeit
gehabt, herauszufinden, wie sie denken. Es hat
mich sicherlich verändert, aber ich kann Ihnen
nicht aus dem Stegreif heraus sagen, wie."
Elvis Presley

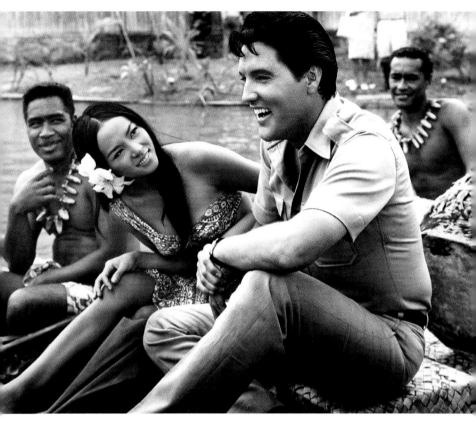

STILL FROM 'PARADISE, HAWAIIAN STYLE' (1966)
The charming young woman at his left appears to be no fan — just honestly curious about him. / Die reizende junge Dame zu seiner Linken scheint kein Fan zu sein, sondern zeigt nur ehrliche Neugier. / La charmante jeune femme à sa gauche n'est finalement pas une de ses fans : elle est simplement curieuse.

« Dans l'armée, j'ai beaucoup appris sur les gens. Je n'avais jamais vécu avec d'autres personnes, et j'ai eu la chance de découvrir leur mode de pensée. Ça m'a changé, certainement, mais je ne saurais dire en quoi. »
Elvis Presley

STILL FROM 'PARADISE, HAWAIIAN STYLE'
(1966)
As a pilot who risks his license to rescue a stranded pal
and his daughter (Donna Butterworth). / Als Pilot setzt
er seinen Flugschein aufs Spiel, um einen gestrandeten
Kumpel und dessen Tochter (Donna Butterworth) zu
retten. / Sous les traits d'un pilote qui risque son
permis de vol pour secourir un ami et sa fille (Donna
Butterworth) échoués quelque part.

STILL FROM 'PARADISE, HAWAIIAN STYLE'
(1966)
One of the many descendants of Lassie (lower right)
wants to barge in on the act. / Einer der vielen
Nachfahren von Lassie (unten rechts) mischt sich ein. /
L'un des nombreux descendants de Lassie (en bas à
droite) tente de faire irruption dans la scène.

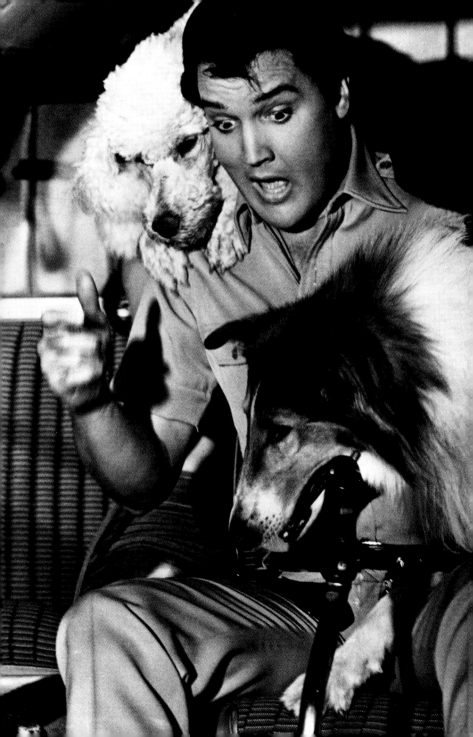

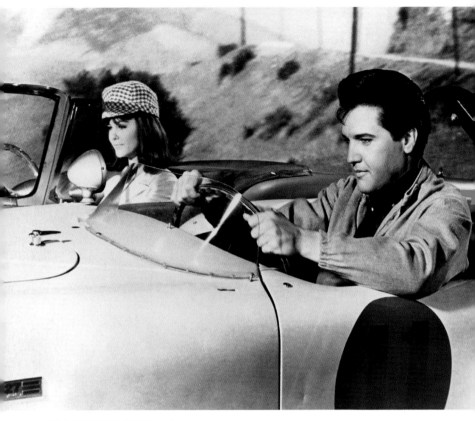

STILL FROM 'SPINOUT' (1966)
Three women vie for his affections, among them a
haughty blueblood (Shelly Fabares). / Drei Frauen
buhlen um seine Gunst, darunter eine arrogante Adlige
(Shelly Fabares). / Trois femmes se battent pour ses
beaux yeux, notamment une jeune femme hautaine de
noble extraction (Shelly Fabares).

"Without Elvis, none of us could have made it."
Buddy Holly

„Ohne Elvis hätte es keiner von uns geschafft."
Buddy Holly

« Sans Elvis, aucun d'entre nous n'y serait arrivé. »
Buddy Holly

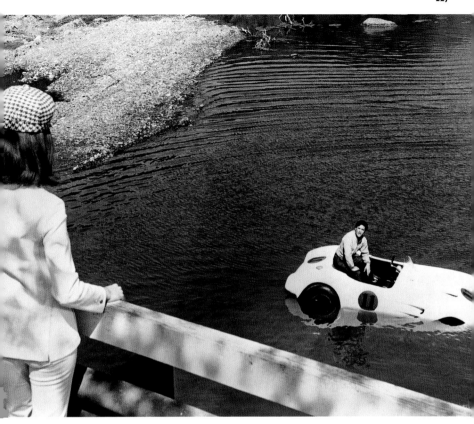

STILL FROM 'SPINOUT' (1966)
The young heiress (Shelly Fabares) looks on as her
intrepid rival (Elvis) must sink or swim. / Die junge Erbin
(Shelly Fabares) schaut zu, wie ihr unerschrockener
Rivale (Elvis) versucht, sich und sein Auto über Wasser
zu halten. / La jeune héritière (Shelly Fabares) observe
son rival intrépide (Elvis). Ce dernier n'a qu'une
alternative : couler ou nager.

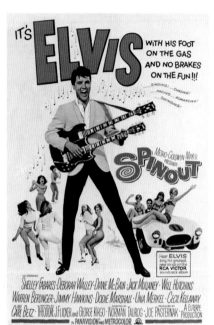

ABOVE/OBEN/CI-DESSUS
POSTER FOR 'SPINOUT' (1966)
Note the double-neck on that guitar. Dressed sharp,
desired by all women, cartoonishly potent. / Elegant
gekleidet, von Frauen umschwärmt und karikaturenhaft
potent – man beachte den doppelten Gitarrenhals! /
Habillé avec classe, désiré de toutes les femmes, une
guitare à double manche à la main : Elvis dans toute sa
gloire.

RIGHT/RECHTS/CI-CONTRE
STILL FROM 'SPINOUT' (1966)
Also vying for Mike's affections are Deborah Walley
(left) and Diane McBain (right). / Auch Deborah
Walley (links) und Diane McBain (rechts) spielen Frauen,
die um Mikes Zuneigung buhlen. / Deborah Walley
(à gauche) et Diane McBain (à droite) rivalisent elles
aussi pour gagner les faveurs de Mike.

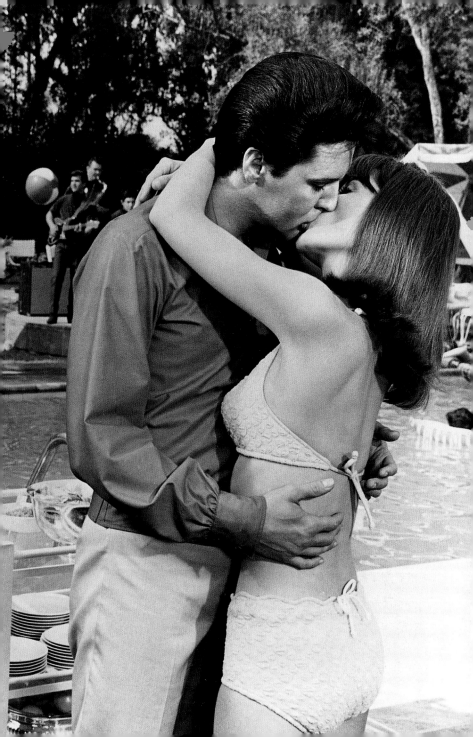

PARAMOUNT
PICTURES
presents

ELVIS PRESLEY
IN
EASY COME, EASY GO
A HAL WALLIS PRODUCTION
TECHNICOLOR

CO-STARRING
DODIE MARSHALL ■ PAT PRIEST ■ PAT HARRINGTON ■ SKIP WARD ■ FRANK McHUGH

Director JOHN RICH Screenplay ALLAN WEISS, ANTHONY LAWRENCE Associate Producer PAUL NATHA

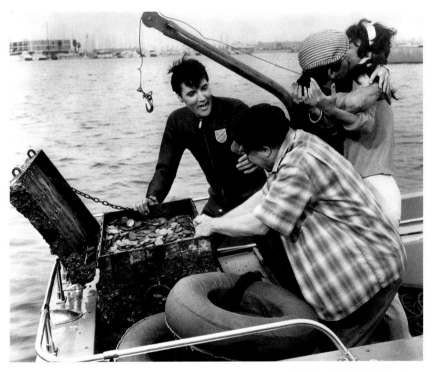

STILL FROM 'EASY COME, EASY GO' (1967)
Elvis plays a navy frogman who finds a chest of gold, just as he's about to retire and become a pop singer. / Elvis spielt hier einen Froschmann in der Marine, der eine Truhe mit Gold findet, kurz bevor er sich aus dem Militärdienst verabschiedet, um Popsänger zu werden. / Elvis incarne un homme-grenouille de la marine qui trouve un coffre rempli d'or, alors qu'il est sur le point de prendre sa retraite pour se reconvertir en chanteur pop.

POSTER FOR 'EASY COME, EASY GO' (1967)
The posters are getting ever more psychedelic as the hallucinatory spell of 1960s pop culture takes hold. / Unter dem Einfluss des Drogenkults der sechziger Jahre wurden auch die Filmplakate immer psychedelischer. / Les affiches deviennent de plus en plus psychédéliques tandis que se propage le charme hallucinatoire de la culture pop des années 1960.

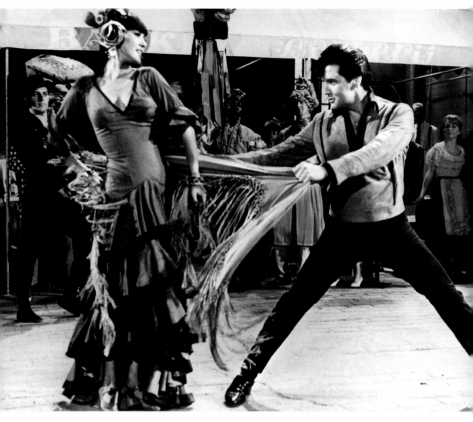

STILL FROM 'DOUBLE TROUBLE' (1967)
The madcap espionage world of James Bond is spoofed
by Elvis. / Elvis nimmt hier die verrückte Spionagewelt
der James-Bond-Filme auf die Schippe. / Elvis dans une
parodie déjantée des films d'espionnage à la James
Bond.

"He is just one big hunk of forbidden fruit."
Anonymous fan

*„Er ist einfach nur ein großes Stück verbotene
Frucht."*
Anonymer Fan

« Elvis, c'est une grosse bouchée du fruit défendu. »
Une fan anonyme

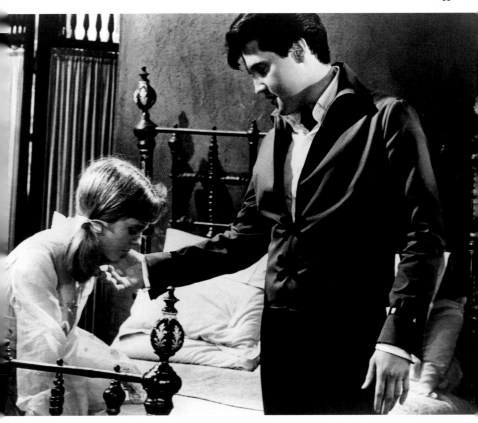

STILL FROM 'DOUBLE TROUBLE' (1967)
When shooting was done, Elvis gave Annette Day (left)
a new Ford Mustang to remember him by. / Nach den
Dreharbeiten schenkte Elvis Annette Day (links) zur
Erinnerung einen neuen Ford Mustang. / À la fin du
tournage, Elvis offre à Annette Day (à gauche) une
nouvelle Ford Mustang en souvenir de lui.

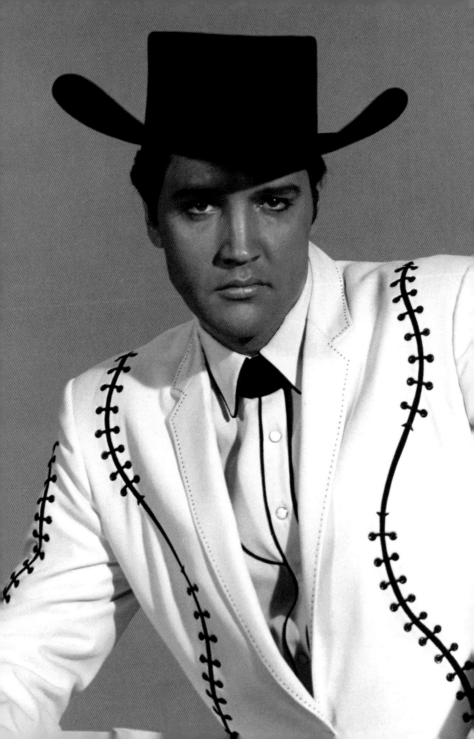

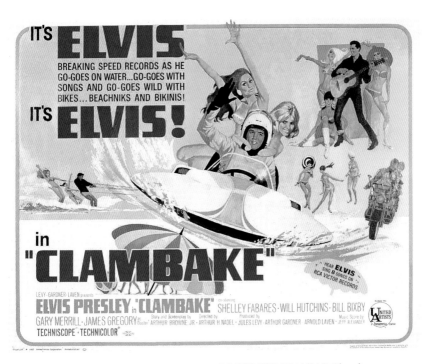

POSTER FOR 'CLAMBAKE' (1967)
To judge by this poster, the hero's efforts are either wildly successful, or just flat-out impossible. / Wenn man nach diesem Filmplakat urteilen soll, dann sind die Bemühungen des Helden entweder ungeheuer erfolgreich oder einfach unmöglich. / À en juger par cette affiche, soit les efforts du héros marchent terriblement bien, soit ils sont tout bonnement invraisemblables.

PORTRAIT FOR 'CLAMBAKE' (1967)
A twist on 'The Prince and the Pauper': Elvis plays an heir to an oil fortune who wants to try life without it. / Eine leicht abgewandelte Version des Märchens *Der Prinz und der Bettelknabe*: Elvis spielt den Erben eines Ölvermögens, der einmal das Leben ohne Reichtum ausprobieren möchte. / Une nouvelle version du *Prince et du Pauvre*: Elvis joue le rôle d'un héritier d'une famille qui a fait fortune dans le pétrole et qui ne demande qu'à vivre humblement.

136

"Since I was two years old, all I knew was Gospel music. That music became such a part of my life it was as natural as dancing. My way of release. During the singing, preachers would cut up all over the place, jumping on the piano, moving every which way. The audience liked them — and I guess I learned a lot from them."
Elvis Presley

„Seit ich zwei Jahre alt war, kannte ich nichts anderes als Gospelmusik. Diese Musik wurde derart zu einem Bestandteil meines Lebens, dass sie so natürlich war wie das Tanzen — meine Art der inneren Befreiung. Während des Singens hüpften die Prediger überall herum, sprangen aufs Klavier, zappelten in alle Richtungen. Das Publikum mochte sie — und ich denke, ich habe viel von ihnen gelernt."
Elvis Presley

« Depuis mes deux ans, la seule musique que je connaissais, c'était le gospel. Cette musique a pris tant d'importance dans ma vie que c'est devenu aussi naturel que la danse. Ma façon à moi de me libérer. Pendant les chansons, les prêtres couraient partout, sautaient sur le piano, gesticulaient dans tous les sens. Le public les aimait ... à mon avis, ils m'ont beaucoup appris. »
Elvis Presley

STILL FROM 'CLAMBAKE' (1967)
Once more into the breach with his favorite co-star Shelly Fabares (gyrating at his side, lower left). / Wieder einmal tanzt seine Lieblingspartnerin Shelly Fabares (unten links) an seiner Seite. / Elvis retrouve sa partenaire préférée, Shelly Fabares (qui virevolte à côté de lui, en bas à gauche).

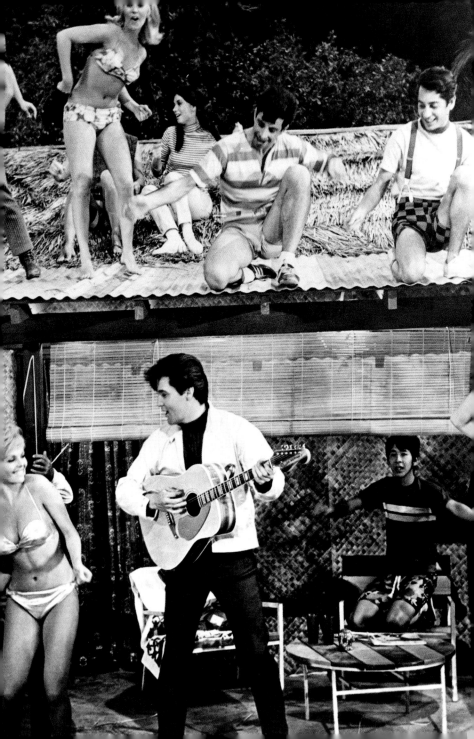

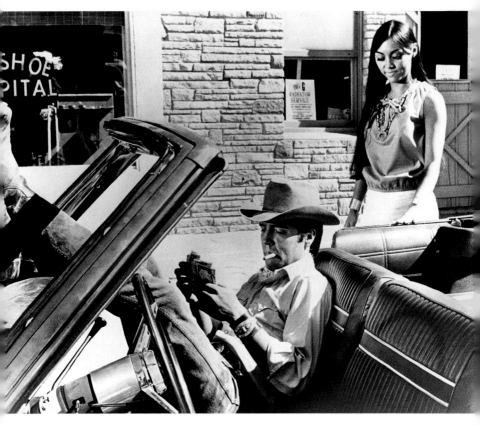

STILL FROM 'STAY AWAY, JOE' (1968)
As in 'Flaming Star,' Elvis plays a Native American,
but this time for cheap laughs. / Wie schon in
Flammender Stern spielt Elvis auch hier einen Indianer,
aber diesmal eher als billige Lachnummer. / Comme
dans *Les Rôdeurs de la plaine*, Elvis incarne un
Amérindien, mais cette fois-ci le film est une comédie
légère.

"I've been very lucky. I happened to come along
at a time in the music business when there was no
trend."
Elvis Presley

„Ich habe sehr viel Glück gehabt. Ich bin zufällig
zu einer Zeit ins Musikgeschäft eingestiegen, als es
keinen Trend gab."
Elvis Presley

« J'ai eu beaucoup de chance. Je suis arrivé à une
époque où il n'existait pas de courant musical dans
l'industrie du disque. »
Elvis Presley

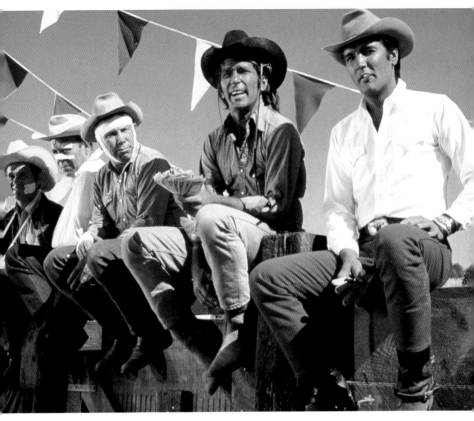

STILL FROM 'STAY AWAY, JOE' (1968)
Joe Lightcloud (Elvis) acquires 20 head of cattle,
but his friends eat one and the rest just scatter. / Joe
Lightcloud (Elvis) erwirbt zwanzig Rinder, aber eines
davon essen seine Freunde auf, und der Rest läuft ihm
davon. / Joe Lightcloud (Elvis) fait l'acquisition de vingt
têtes de bétail, mais ses amis en mangent une et les
autres se dispersent.

*"My favorite actors are Marlon Brando and
Spencer Tracy. James Dean was a genius."*
Elvis Presley

*„Meine Lieblingsschauspieler sind Marlon Brando
und Spencer Tracy. James Dean war ein Genie."*
Elvis Presley

*« Mes acteurs préférés sont Marlon Brando et
Spencer Tracy. James Dean était un génie. »*
Elvis Presley

STILL FROM 'STAY AWAY, JOE' (1968)
At gunpoint, caught romancing the local sheriff's
daughter (Quentin Dean). / In den Gewehrlauf blickt ein
überraschter Joe, den man mit der Tochter (Quentin
Dean) des Sheriffs in flagranti erwischt hat. / Mis en
joue alors qu'il est en pleins ébats avec la fille du shérif
(Quentin Dean).

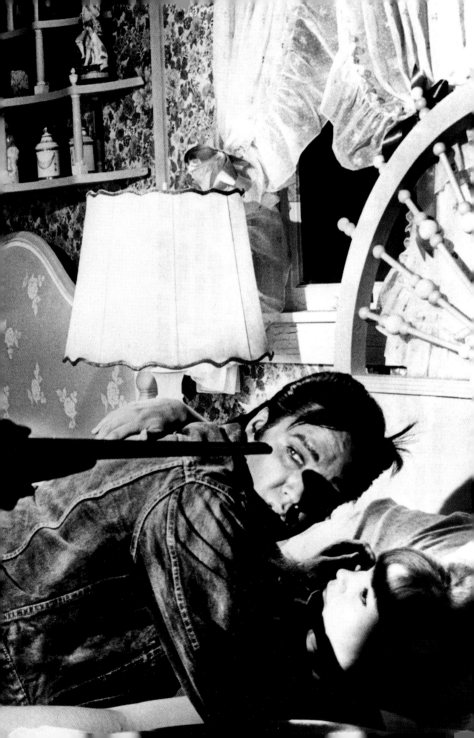

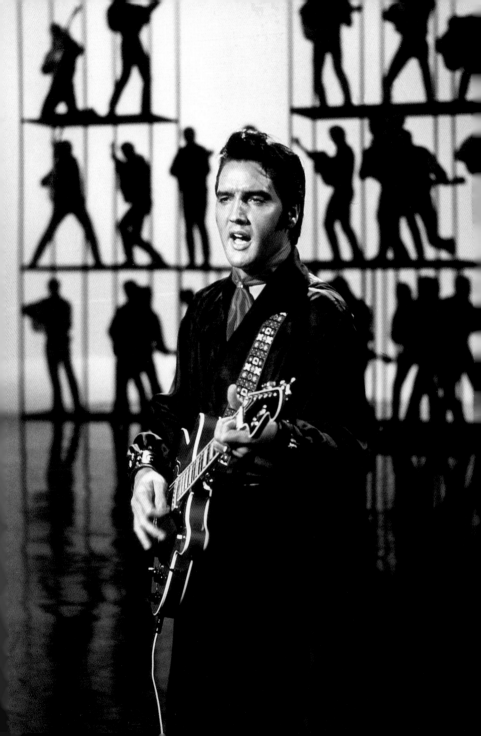

"Finest music of his life. If there was ever music that bleeds, this was it. Nothing came easy that night and he gave everything that he had – more than anyone knew he had."
Greil Marcus

"They ruined it; you should have seen it before they edited it."
Phil Spector

„*Die beste Musik seines Lebens. Wenn es jemals Musik gab, die blutet, dann war es diese. Nichts fiel ihm an diesem Abend leicht, und er gab alles, was in ihm steckte – mehr als irgendjemand in ihm vermutet hätte.*"
Greil Marcus

„*Sie haben es ruiniert; Sie hätten es sehen sollen, bevor sie es geschnitten haben.*"
Phil Spector

« *La meilleure musique de sa vie. Si une musique peut saigner, c'était celle-ci. Rien n'a été facile cette nuit-là et il a tout donné, il a même donné plus que ce qu'on pouvait imaginer.* »
Greil Marcus

« *Ils ont complètement gâché l'émission. Vous auriez dû voir ce que c'était avant les coupures.* »
Phil Spector

STILL FROM 'ELVIS' (1968, TV)
A highlight of his career was this ambitious TV special, mixing old hits with new songs and folk songs. / Ein Höhepunkt seiner Karriere war dieses ehrgeizige Fernsehspecial, in dem alte Hits mit neuen Songs und Folkmusik vermischt wurden. / Cette ambitieuse émission de télévision est un sursaut dans sa carrière : il y alterne de vieux tubes, des titres inédits et des chansons folk.

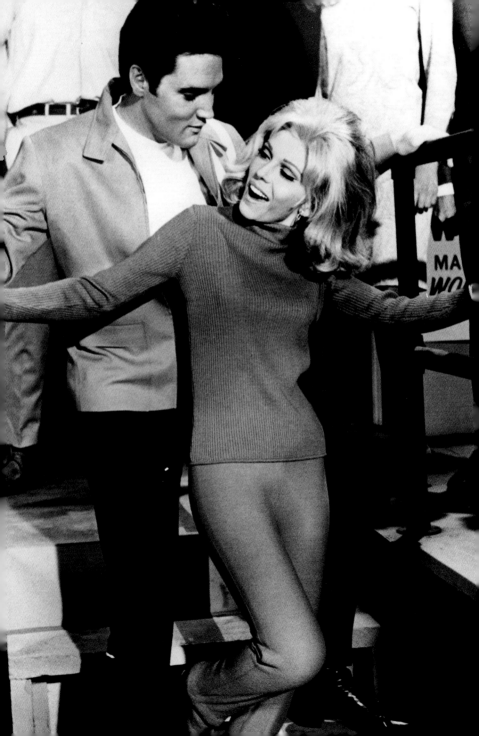

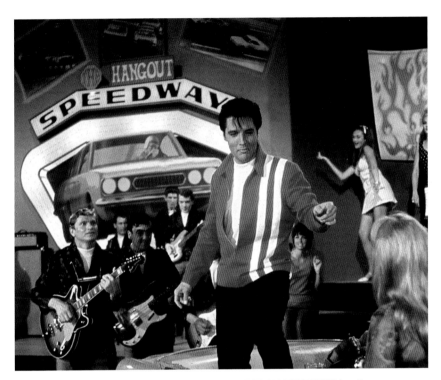

STILL FROM 'SPEEDWAY' (1968)
Playing yet another race-car driver who can, at a fingersnap, move and sing ... just like Elvis. / Er spielt einen ganz normalen Rennfahrer, der auf Kommando singen und tanzen kann ... ganz so wie Elvis. / Dans la peau d'un pilote de course qui peut, en un claquement de doigt, bouger et chanter ... exactement comme Elvis.

PAGES 146/147
STILL FROM 'SPEEDWAY' (1968)
The raucous final number, 'There Ain't Nothin' like a Song.' The set inspired Jack Rabbit Slim's in Quentin Tarantino's 'Pulp Fiction' (1994). / Die Kulissen dienten als Vorlage für Jack Rabbit Slim's in Quentin Tarantinos *Pulp Fiction* (1994). / Un numéro final cacophonique. Le décor a inspiré celui du Jack Rabbit Slim's dans *Pulp Fiction* de Quentin Tarantino (1994).

STILL FROM 'SPEEDWAY' (1968)
Movin' and a groovin', as per usual, this time with Nancy Sinatra. / Das übliche Spielchen, diesmal mit Nancy Sinatra. / Il chante et danse comme à son habitude, mais cette fois avec Nancy Sinatra.

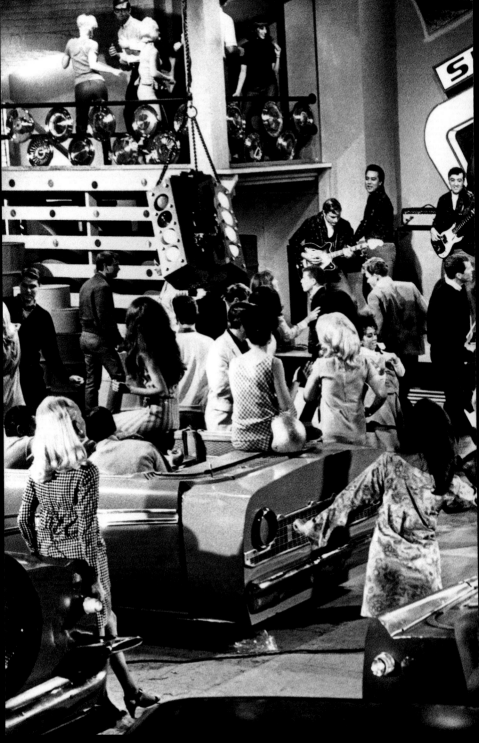

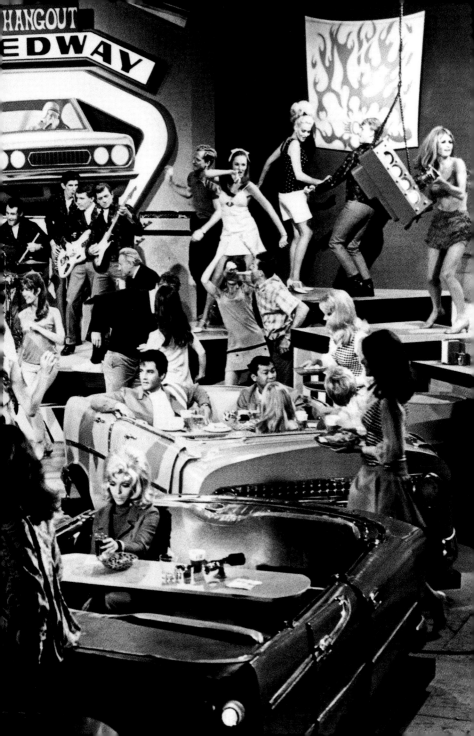

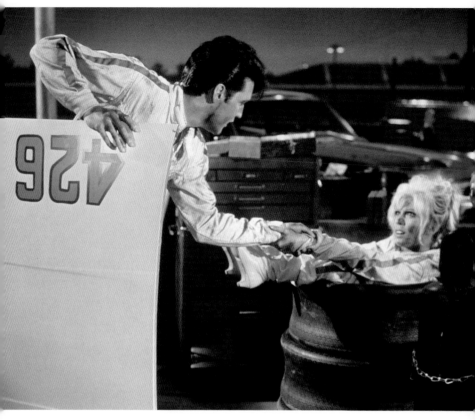

STILL FROM 'SPEEDWAY' (1968)
Getting off on the wrong foot with leading lady Nancy
Sinatra. / Bei der ersten Begegnung mit seiner
Filmpartnerin Nancy Sinatra geht einiges schief. / Pour
son premier duo à l'écran avec Nancy Sinatra, Elvis part
du mauvais pied.

*"... This is, after all, just another Presley movie —
which makes no use at all of one of the most
talented, important, and durable performers of our
time. Music, youth, and customs were much
changed by Elvis Presley 12 years ago; from the
26 movies he has made since he sang 'Heartbreak
Hotel' you would never guess it."*
Renata Adler, *New York Times* critic, reviewing *Speedway*

*„.... Das ist schließlich auch nur ein weiterer Presley-
Film — der einen der begabtesten, wichtigsten und
beständigsten Darsteller unserer Zeit völlig verheizt.
Vor zwölf Jahren hat Elvis Presley unsere Musik,
unsere Jugend und unsere Gewohnheiten grund-
legend verändert, aber wenn man sich die 26 Filme
anschaut, die er gedreht hat, seit er ‚Heartbreak
Hotel' sang, würde man das nie für möglich halten."*
Renata Adler, Kritikerin der *New York Times*,
über *Speedway*

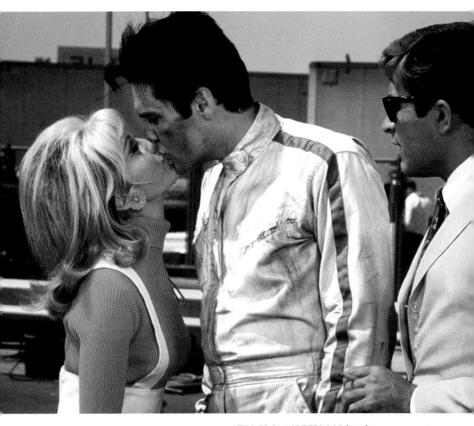

STILL FROM 'SPEEDWAY' (1968)
Winning Nancy Sinatra, against his chief rival Bill Bixby
(right). / Am Ende gewinnt natürlich er das Herz von
Susan (Nancy Sinatra) und nicht sein Erzrivale Kenny
(Bill Bixby, rechts). / Il séduit Nancy Sinatra et dame le
pion à son principal rival, Bill Bixby (à droite).

« ... Après tout, ce n'est qu'un film de Presley de
plus, un film qui ne se sert pas le moins du monde
de l'un des acteurs les plus talentueux, les plus
importants et les plus marquants de notre époque.
Ces douze dernières années, la musique, la
jeunesse et les modes ont connu de grands
changements avec Elvis Presley, mais au vu des
26 films qu'il a tournés depuis qu'il a chanté
"Heartbreak Hotel", c'est difficile à imaginer. »
Renata Adler, critique du New York Times, à propos
d'À plein tubes

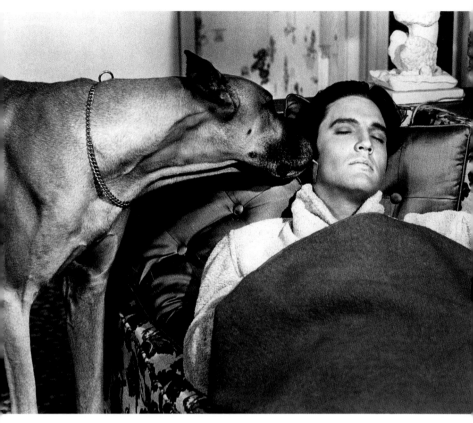

**STILL FROM 'LIVE A LITTLE, LOVE A LITTLE'
(1968)**
The intention with this film was to upgrade Elvis to a
sexier, more sophisticated style. Nobody told the dog. /
Mit dem Film wollte man Elvis eigentlich zu einem etwas
erotischeren, niveauvolleren Image verhelfen. Der Hund
war offenbar nicht eingeweiht. / En jouant dans ce film,
Elvis espère retrouver une image plus sexy et plus
sophistiquée. Personne n'a pensé à prévenir le chien.

*"When he started, he couldn't spell Tennessee.
Now he owns it."*
Bob Hope

*„Als er anfing, konnte er nicht einmal 'Tennessee'
buchstabieren. Heute gehört es ihm."*
Bob Hope

*« Quand il a débuté, il pouvait à peine épeler le
mot "Tennessee". Aujourd'hui, le Tennessee lui
appartient. »*
Bob Hope

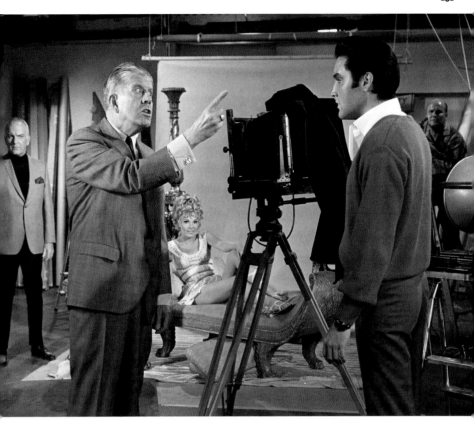

STILL FROM 'LIVE A LITTLE, LOVE A LITTLE' (1968)
As a daring photographer, chastised by Rudy Vallee, an advertising executive with conservative tastes. / Als Fotograf gewagter Aufnahmen wird er von Penlow (Rudy Vallee), einem konservativen Werbefachmann, gerügt. / Elvis interprète un photographe audacieux corrigé par Rudy Vallee, un cadre de la pub aux goûts conservateurs.

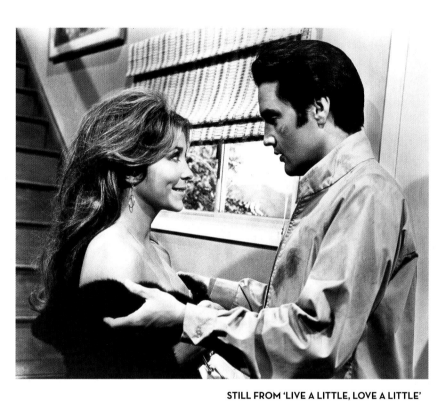

STILL FROM 'LIVE A LITTLE, LOVE A LITTLE' (1968)
When not shooting ads, he takes photos for 'Classic Cat,' a parody of Hugh Hefner's 'Playboy' magazine. / Wenn er keine Werbeaufnahmen macht, fotografiert er für *Classic Cat*, eine Parodie auf Hugh Hefners *Playboy*. / Lorsqu'il n'est pas en tournage pour la publicité, il fait des photos pour *Classic Cat*, une parodie du magazine *Playboy* de Hugh Hefner.

STILL FROM 'LIVE A LITTLE, LOVE A LITTLE' (1968)
Michele Cary (left), free-spirited, bawdy — a decided break from the virgins of early Elvis pictures. / Die freigeistige, freizügige Michele Cary (links) unterscheidet sich deutlich von den Jungfrauen der frühen Elvis-Filme. / Michele Cary (à gauche), libérée et grivoise ... un changement radical quand on pense aux vierges effarouchées des premiers films d'Elvis.

PAGES 154/155
STILL FROM 'CHARRO!' (1968)
As Jess Wade, an outlaw trying to go straight, Elvis diligently raids Clint Eastwood territory. / Als Jess Wade, ein reuevoller Gesetzloser, bedient sich Elvis gnadenlos bei Clint Eastwood. / Dans la peau de Jess Wade, un hors-la-loi qui tente de filer droit, Elvis fait une incursion sur le territoire de Clint Eastwood.

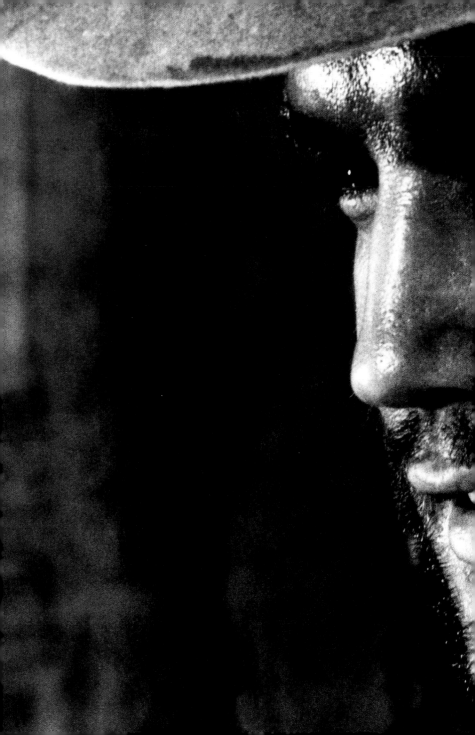

STILL FROM 'CHARRO!' (1968)
Elvis was well suited to the western, and it is a pity this one came so late in his movie career. / Elvis passte gut zum Western, und es ist bedauerlich, dass dieser erst gegen Ende seiner Karriere kam. / Elvis est taillé pour les westerns. Dommage que ce film arrive si tard dans sa carrière d'acteur.

STILL FROM 'CHARRO!' (1968)
No musical numbers here. "I play a gunfighter," said Elvis, "And I just couldn't see a singing gunfighter." / Hier gab es keine Musikeinlagen. „Ich spiele einen Revolverhelden," sagte Elvis, „und ich konnte mir einfach keinen singenden Revolverhelden vorstellen." / Aucun tour de chant dans ce film. « Je joue le rôle d'un type avec un pistolet, dit Elvis. Je vois mal ce genre de type pousser la chansonnette. »

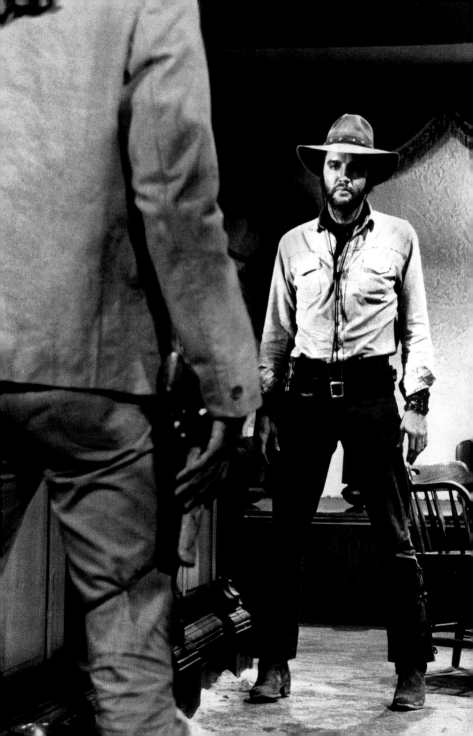

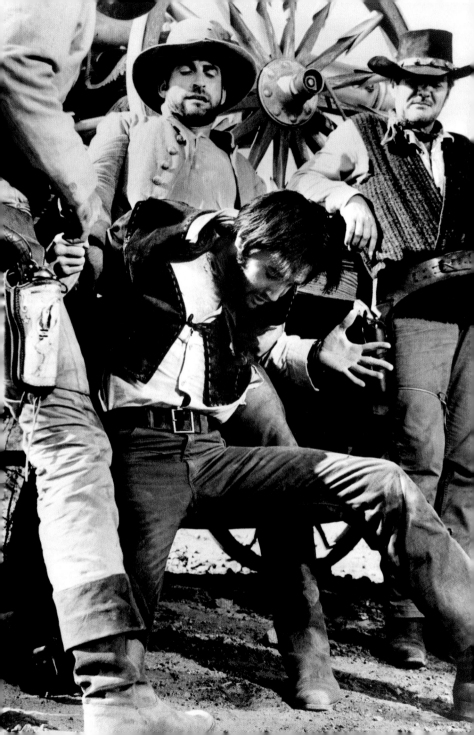

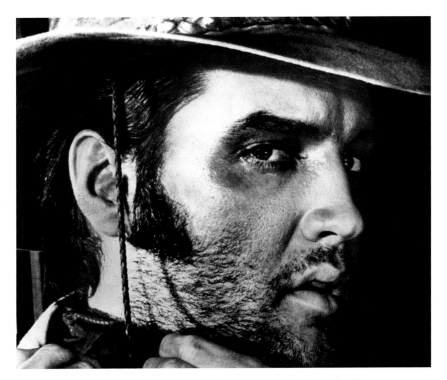

STILL FROM 'CHARRO!' (1968)
The film did well. But there were no more in this interesting new style. / Der Film war erfolgreich, aber es gab keine weiteren in diesem für ihn interessanten, neuen Stil. / Le film a bien marché. Mais il n'y en aura pas d'autres dans ce nouveau style intéressant.

STILL FROM 'CHARRO!' (1968)
His greatest obstacles to making a new, law-abiding life are his old friends in the outlaw gang. / Sein größtes Hindernis auf dem Weg zum gesetzestreuen Bürger sind seine alten Kumpane aus der Gangsterbande. / Ses plus grands obstacles pour recommencer une vie honnête sont ses anciens amis de la bande de hors-la-loi.

**STILL FROM 'THE TROUBLE WITH GIRLS'
(1969)**
The story centers on a 'chautauqua,' a traveling
educational show which tours rural areas. / Die
Geschichte dreht sich um eine „Chautauqua", eine Art
Wanderzirkus mit Bildungsanspruch, der einst übers
Land zog. / L'histoire est centrée sur un « chautauqua »,
un spectacle pédagogique qui fait la tournée des
campagnes.

**STILL FROM 'THE TROUBLE WITH GIRLS'
(1969)**
Elvis was tired, and his movie contracts were about to
expire. He is only onscreen for a third of this one. / Elvis
war erschöpft, und seine Filmverträge liefen bald aus.
In diesem Film ist er nur noch ein Drittel der Laufzeit
auf der Leinwand zu sehen. / Elvis est fatigué et ses
contrats de cinéma vont bientôt expirer. Il n'apparaît à
l'écran que dans un tiers de ce film.

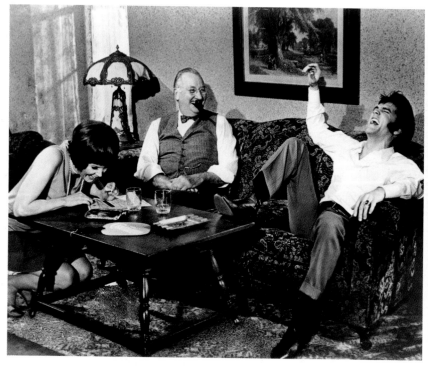

**STILL FROM 'THE TROUBLE WITH GIRLS'
(1969)**
A scene of some merriment. / Eine Szene der
Heiterkeit. / Une scène de franche rigolade.

**STILL FROM 'THE TROUBLE WITH GIRLS'
(1969)**
In a clinch with leading lady Marilyn Mason. / Im Clinch
mit Filmpartnerin Marilyn Mason. / Dans les bras de sa
partenaire Marilyn Mason.

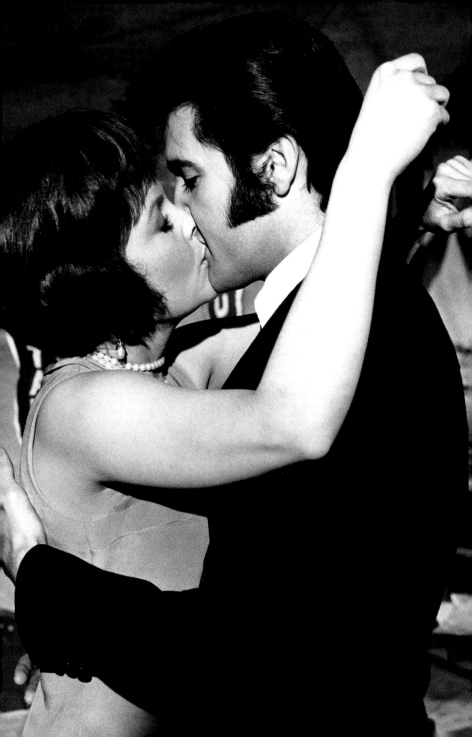

STILL FROM 'CHANGE OF HABIT' (1969)
Olivia (Mary Tyler Moore) is secretly a nun. We know, but the good doctor does not. / Olivia (Mary Tyler Moore) ist insgeheim eine Nonne. Wir wissen es, aber der gute Doktor hat keine Ahnung. / En secret, Olivia (Mary Tyler Moore) est une religieuse. Nous le savons, mais le bon docteur l'ignore.

STILL FROM 'CHANGE OF HABIT' (1969)
In his last dramatic feature, Elvis plays an idealistic doctor, opposite Mary Tyler Moore. / In seinem letzten Drama spielt Elvis einen idealistischen Arzt an der Seite von Mary Tyler Moore. / Dans son dernier rôle dramatique, Elvis interprète un docteur idéaliste face à Mary Tyler Moore.

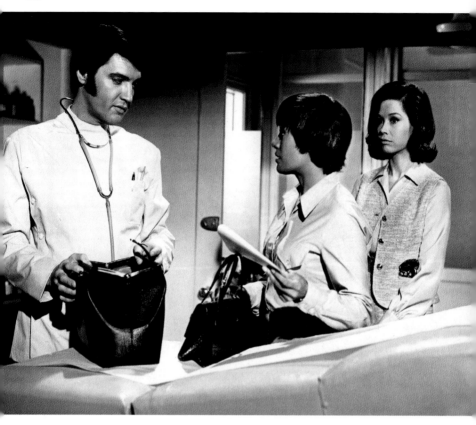

STILL FROM 'CHANGE OF HABIT' (1969)
Physically fit, and in sturdy creative form. Does this look
like a man who'll be dead in half a decade? / Körperlich
fit und auch kreativ gut drauf — wer hätte gedacht,
dass dieser Mann in einem halben Jahrzehnt tot sein
würde? / Elvis est dans une forme physique et artistique
éblouissante. Qui aurait pu deviner qu'il disparaîtrait
cinq ans plus tard ?

*"I don't know anybody my age that did not sing like
him, at one time or another."*
Bob Dylan

*„Ich kenne niemanden in meinem Alter, der nicht
irgendwann einmal wie er gesungen hat."*
Bob Dylan

*« Je ne connais personne de mon âge qui n'a pas
chanté comme lui, à un moment ou à un autre. »*
Bob Dylan

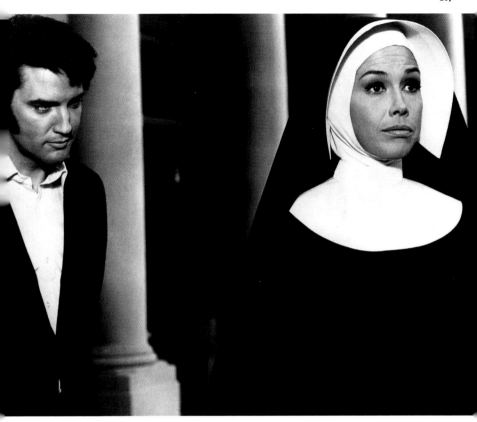

STILL FROM 'CHANGE OF HABIT' (1969)
This modest little film offers a gentle, endearing
valedictory to his career as an actor. / Dieser
bescheidene kleine Film ist ein sanfter, liebevoller
Abgesang auf seine Schauspielkarriere. / Ce modeste
petit film est un adieu touchant à sa carrière d'acteur.

"Touring is hard, but I'm only happy twice a day –
when I'm onstage."
Elvis Presley

„Tourneen sind hart, aber ich bin nur zweimal am
Tag glücklich – wenn ich auf der Bühne stehe."
Elvis Presley

« Les tournées, c'est éprouvant, mais je ne suis
heureux que deux fois par jour : quand je suis sur
scène. »
Elvis Presley

**STILL FROM 'ELVIS: THAT'S THE WAY IT IS'
(1970)**
Perhaps the only role he could embrace, or tolerate
anymore, was that of himself, making music. / Ver-
mutlich war die einzige Rolle, in die er sich noch hin-
einversetzen vermochte, oder die er überhaupt noch
ausstehen konnte, er selbst, Elvis, der Musiker. / Le seul
rôle qu'il pouvait encore jouer – ou en tout cas accepter
de jouer : son propre rôle, une guitare à la main.

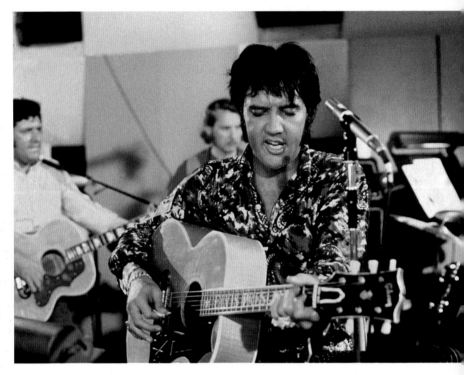

**STILL FROM 'ELVIS: THAT'S THE WAY IT IS'
(1970)**
All the vitality of his early work is still there at his
fingertips. / Die ganze Vitalität seiner frühen Arbeit
steckt ihm noch immer in den Fingerspitzen. / Toute la
vitalité de ses débuts est encore là, au bout de ses
doigts.

**STILL FROM 'ELVIS: THAT'S THE WAY IT IS'
(1970)**
In 1970, lean and fit, he was even able to wear that loud
white jumpsuit in showman-like style. / Als er 1970 noch
schlank und fit war, konnte er den strahlendweißen
Overall sogar noch wie ein echter Showmann tragen. /
En 1970, mince et en forme, il peut encore se permettre
de porter cette combinaison tapageuse comme une
vraie bête de scène.

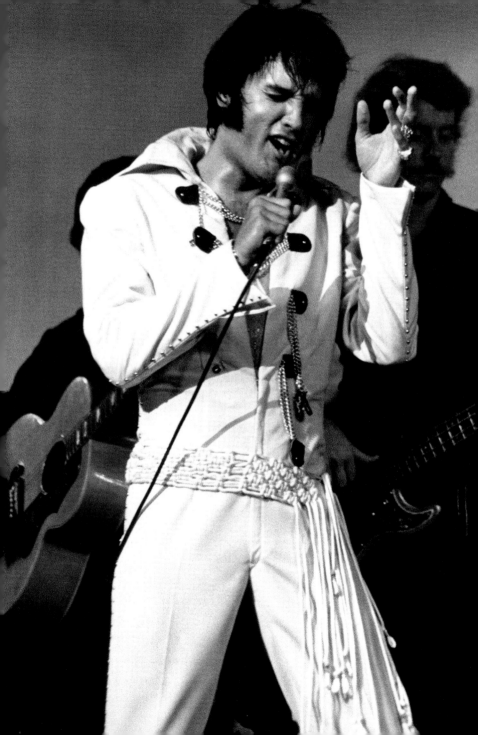

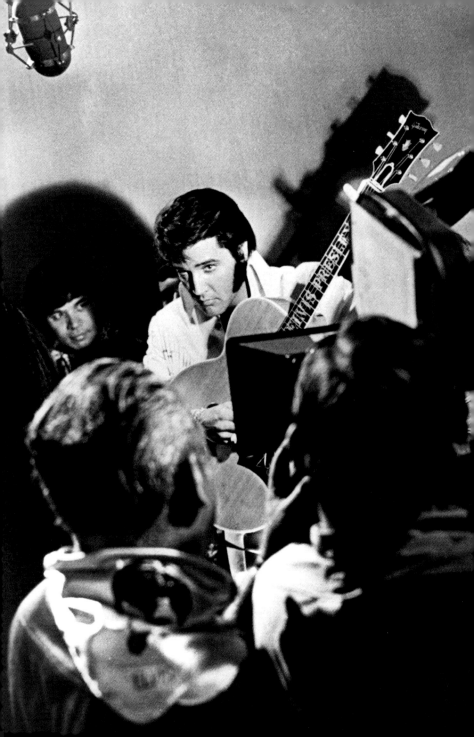

"I remember when I was nine years old and I was sittin' in front of the TV set and my mother had Ed Sullivan on, and on came Elvis. I remember right from that time, I looked at her and said, 'I wanna be just — like — that!'"
Bruce Springsteen

„*Ich kann mich noch daran erinnern, als ich neun Jahre alt war und vor dem Fernseher saß und meine Mutter die Ed-Sullivan-Show eingeschaltet hatte und Elvis dort auftrat. Ich weiß noch genau, wie ich sie damals anschaute und sagte: ‚Ich will mal genau so werden wie der!'*"
Bruce Springsteen

« *Je me rappelle, quand j'avais neuf ans, j'étais assis devant la télé ; ma mère avait mis Ed Sullivan. Elvis est arrivé. Je me rappelle que c'est à ce moment-là que je lui ai dit : "Je veux être … exactement comme ça !"* »
Bruce Springsteen

ON THE SET OF 'ELVIS ON TOUR' (1972)
Elvis in his prime, at the cusp of his decline, but fittingly casting a giant shadow. / Elvis auf dem Höhepunkt und kurz vor dem Abstieg: passenderweise wirft er einen großen Schatten. / Elvis dans la fleur de l'âge et au bord du déclin. Pourtant, son ombre de géant lui va comme un gant.

"He taught white America to get down."
James Brown on Elvis

„Er hat dem weißen Amerika beigebracht, zur Sache zu kommen."
James Brown über Elvis

« Il a appris aux Blancs américains à s'éclater. »
James Brown à propos d'Elvis

RIGHT/RECHTS/CI-CONTRE
STILL FROM 'ELVIS ON TOUR' (1972)
A signature pose, costumed for heaven, and giving his all. / In einer typischen Pose, kostümiert für den Himmel, gibt er noch einmal alles, was in ihm steckt. / Une pose typique d'Elvis. En tenue pour le paradis, il donne tout ce qu'il a.

PAGES 176/177
STILL FROM 'ELVIS ON TOUR' (1972)
His cloaked jumpsuit became the trademark of his last decade. / Der Overall mit Cape wurde im letzten Jahrzehnt seines Lebens zu seinem Markenzeichen. / Sa combinaison et sa cape sont devenues la marque de fabrique de ses dix dernières années d'existence.

PAGE 178
PORTRAIT (1958)
Elvis Presley made 31 movies, most too silly to survive without him, yet every one made money. Such is star power. / Elvis Presley drehte 31 Filme, von denen die meisten so albern waren, dass sie ohne ihn längst vergessen wären, und doch spielte jeder von ihnen Gewinn ein. Das ist wahre Star-Power. / Elvis a tourné dans 31 films, dont de nombreux nanars aujourd'hui oubliés. Pourtant tous ont été « payants » ; on reconnaît là le pouvoir des stars.

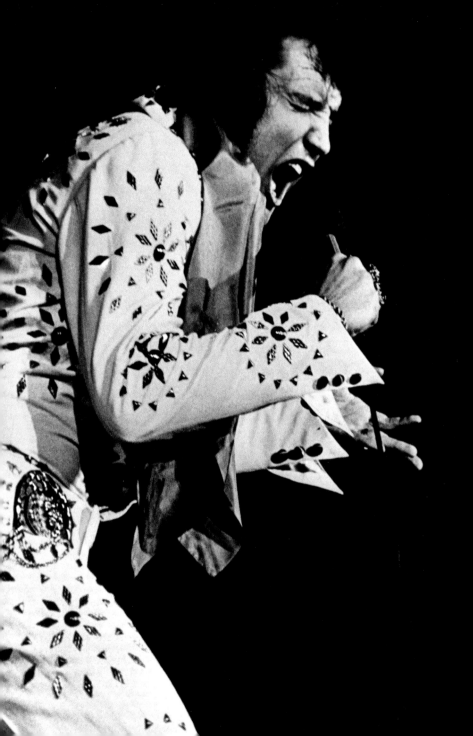

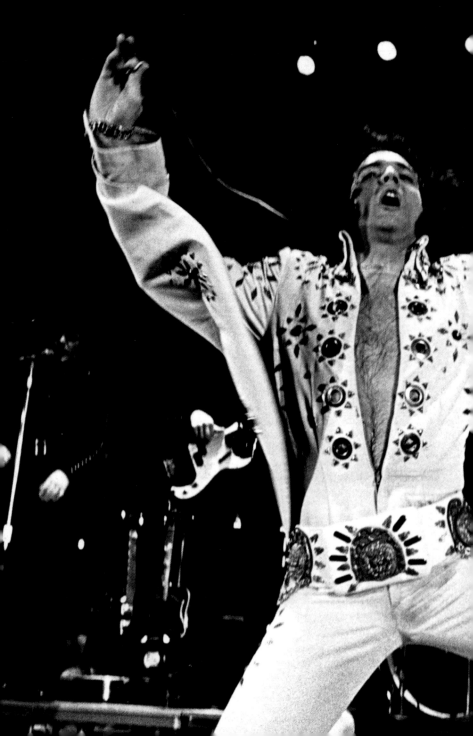

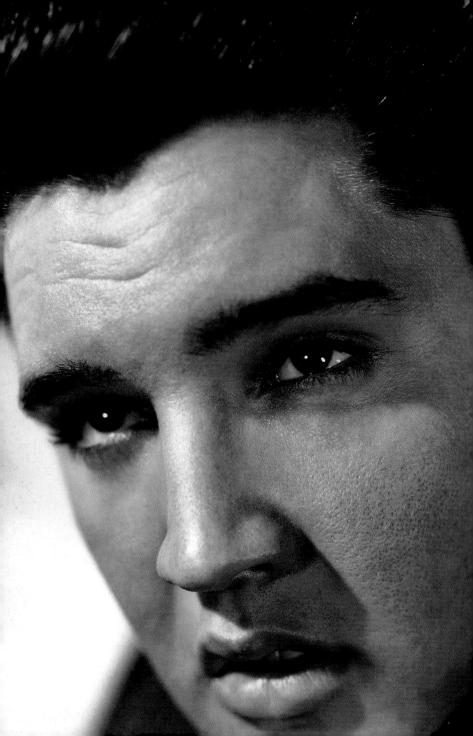

3
CHRONOLOGY

CHRONOLOGIE

CHRONOLOGIE

CHRONOLOGY

8 January 1935 Elvis Aaron Presley is born in Tupelo, Mississippi. Identical twin Jesse dies hours later.

3 October 1946 Sings in a talent contest, broadcast live over radio. Takes 2nd prize.

1953 Memphis. Drives truck for Crown Electric.

4 January 1954 Music impresario Sam Phillips, owner of Sun Records, overhears Elvis recording 'Casual Love Affair,' on a $4 acetate record at Memphis Recording Service, and is impressed. The pair cut a number of records at Sun over the next 12 months, including Elvis' first commercial hit, 'That's All Right, Mama.' Quits his job at Crown Electric.

1955–1956 Buys a pink Cadillac, is launched to national prominence through a variety of TV appearances, signs with Colonel Tom Parker, who becomes his manager.

August 1956 Col. Parker signs a deal to produce a line of 'Elvis' memorabilia — pictures that glow in the dark, denim jeans, sweaters, bracelets, ties, hats, dolls, greeting cards, pencils, buttons, hairbrushes, busts, bookends, guitars, shoes, chains, underpants, handkerchiefs, wallets, photographs, bolo ties, T-shirts, photograph albums, belts, stuffed hound dogs, stuffed teddy bears, necklaces, colognes, lipsticks (Heartbreak Hotel Pink, Tutti Frutti Red, and Hound Dog Orange), bubble gum cards, etc. etc. Wendy Sauers lists twice as many items in *Elvis Presley: A Complete Reference*. Profits from this imponderabilia come to $26 million within the first year.

1956–1958 Three movies define Elvis as a film star: *Love Me Tender* (1956), *Jailhouse Rock* (1957), and *King Creole* (1958).

1958 His mother dies. Private Elvis Presley, US53310761 is granted leave from the US Army to be at her bedside.

August 1959 Meets Priscilla Beaulieu in Bremerhaven, West Germany.

1960–1967 Discharged from military service, Elvis makes one continuous kitschy film under many titles: *Blue Hawaii* (1961), *Follow That Dream* (1962), *Kid Galahad* (1962), *Girls! Girls! Girls!* (1962) …

1 May 1967 Marries Priscilla in Las Vegas.

February 1968 Daughter Lisa-Marie Presley is born.

3 December 1968 Hosts a forward-looking (high energy, even folkloric) television special on NBC.

21 December 1970 A friendly call on President Richard Nixon, who appoints Elvis a Federal Narcotics Agent.

1971–1977 A prosperous, forgettable round of Vegas concerts. Elvis piles on weight and damages his health with a complex array of addictions to deadly pharmaceuticals.

16 August 1977 Found dead at 2:30 pm. He had disappeared into his private bathroom earlier that morning with a book he was reading, *A Scientific Search for the Face of Jesus*, and perished of a heart attack.

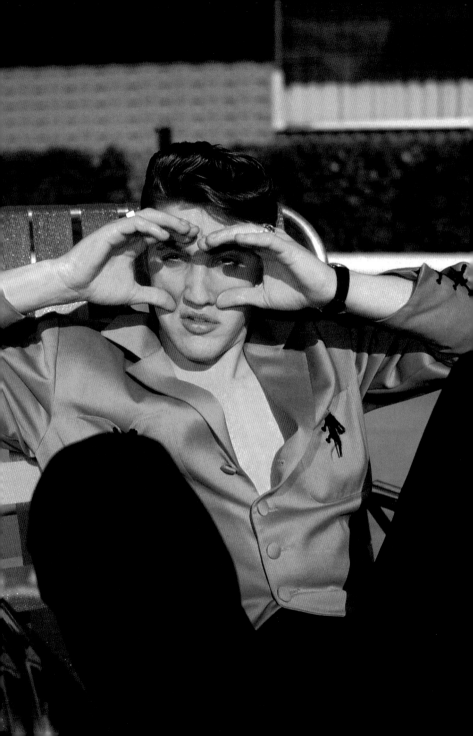

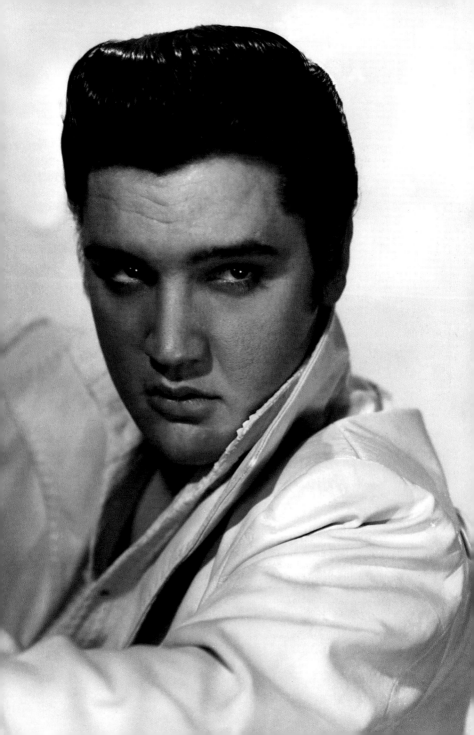

CHRONOLOGIE

8. Januar 1935 Elvis Aaron Presley kommt in Tupelo (Mississippi) zur Welt. Sein eineiiger Zwillingsbruder Jesse stirbt nach wenigen Stunden.

3. Oktober 1946 Presley singt bei einem Talentwettbewerb, der live im Rundfunk übertragen wird, und gewinnt den zweiten Preis.

1953 Memphis. Arbeitet als Lkw-Fahrer für Crown Electric.

4. Januar 1954 Musikimpresario Sam Phillips, der Eigentümer von Sun Records, hört, wie Elvis beim Memphis Recording Service für 4 Dollar „Casual Love Affair" auf eine Acetatplatte aufnimmt und ist beeindruckt. Gemeinsam produzieren die beiden in den folgenden zwölf Monaten eine Reihe von Schallplatten bei Sun, darunter Elvis' ersten kommerziellen Erfolg, „That's All Right, Mama". Er hängt seinen Job bei Crown Electric an den Nagel.

1955–1956 Er kauft sich einen pinkfarbenen Cadillac und wird durch eine Reihe von Fernsehauftritten im ganzen Land berühmt. Er wird von Manager Colonel Tom Parker unter Vertrag genommen.

August 1956 Colonel Parker schließt einen Vertrag über die Herstellung von Elvis-Andenken ab: Bilder, die im Dunkeln leuchten, Kaugummikarten, Grußkarten, Fotos, Fotoalben, Jeans, Pullover, T-Shirts, Unterhosen, Gürtel, Armbänder, Halsbänder, Ketten, Krawatten, Knöpfe, Hüte, Schuhe, Puppen, Taschentücher, Brieftaschen, Geldbörsen, Plüschhunde, Teddybären, Bleistifte, Buchstützen, Gitarren, Haarbürsten, Eau de Cologne, Lippenstifte (in „Heartbreak-Hotel-Pink", „Tutti-Frutti-Rot" und „Hound-Dog-Orange") und so weiter und so fort. Wendy Sauers führt in *Elvis Presley: A Complete Reference* doppelt so viele Gegenstände auf. Der Erlös daraus beläuft sich bereits im ersten Jahr auf 26 Millionen Dollar.

1956–1958 Drei Filme machen Elvis zum Filmstar: *Pulverdampf und heiße Lieder* (1956), *Rhythmus hinter Gittern* (1957) und *Mein Leben ist der Rhythmus* (1958).

1958 Seine Mutter stirbt. Der Gefreite Elvis Presley, US53310761, erhält Sonderurlaub von der US-Armee, um in den letzten Stunden bei ihr zu sein.

August 1959 Presley lernt in Bremerhaven Priscilla Beaulieu kennen.

1960–1967 Nach seiner Entlassung aus dem Militärdienst dreht Elvis unter vielen verschiedenen Titeln den immergleichen Kitschfilm: *Blaues Hawaii* (1961), *Ein Sommer in Florida* (1962), *Harte Fäuste, heiße Liebe* (1962), *Girls! Girls! Girls!* (1962) …

1. Mai 1967 Er heiratet Priscilla in Las Vegas.

Februar 1968 Tochter Lisa-Marie Presley kommt zur Welt.

3. Dezember 1968 Auf NBC präsentiert er ein vielversprechendes Fernsehspecial (energiegeladen, beinahe folkig).

21. Dezember 1970 Er wird freundlicherweise vom Präsidenten Richard Nixon empfangen, der ihn zum Bundesdrogenbeauftragten ernennt.

1971–1977 Eine finanziell einträgliche, aber wenig denkwürdige Reihe von Konzerten in Las Vegas. Elvis nimmt immer 7mehr zu und ruiniert seine Gesundheit durch seine Medikamentenabhängigkeit.

16. August 1977 Um 14.30 Uhr wird er tot aufgefunden. Er hatte sich am Vormittag mit dem Buch *A Scientific Search for the Face of Jesus* („Eine wissenschaftliche Suche nach dem Antlitz Jesu"), das er gerade las, in sein privates Badezimmer zurückgezogen und starb an einem Herzinfarkt.

CHRONOLOGIE

8 janvier 1935 Elvis Aron Presley voit le jour à Tupelo, au Mississippi. Jesse, sa vraie jumelle, meurt quelques heures plus tard.

3 octobre 1946 Participe à un concours de jeunes talents diffusé en direct à la radio et remporte le deuxième prix.

1953 À Memphis. Conduit des camions pour Crown Electric.

4 janvier 1954 Sam Phillips, agent de l'industrie du disque et propriétaire de Sun Records, entend par hasard Elvis enregistrer « Casual Love Affair » sur un disque vinyle à quatre dollars, au Memphis Recording Service, et est vivement impressionné. Les deux hommes enregistrent un grand nombre de titres avec Sun pendant les douze mois suivants, notamment le premier tube commercial d'Elvis, « That's All Right, Mama ». Elvis quitte son travail chez Crown Electric.

1955–1956 S'achète une Cadillac rose, lance sa carrière nationale avec diverses apparitions télévisées, signe avec le colonel Tom Parker, qui devient son manager.

Août 1956 Le colonel Parker signe un contrat pour produire une ligne d'articles à l'effigie d'Elvis : photos luminescentes, jeans, pulls, bracelets, cravates, chapeaux, poupées, cartes de vœux, stylos, boutons, brosses à cheveux, bustes, serre-livres, guitares, chaussures, chaînes, sous-vêtements, mouchoirs de poche, portefeuilles, photos, cravates western, T-shirts, albums photos, ceintures, chiens et ours en peluche, colliers, parfums, rouges à lèvres (rose pour « Heartbreak Hotel », rouge pour « Tutti Frutti » et orange pour « Hound Dog »), cartes à collectionner, etc. Wendy Sauers présente une liste deux fois plus longue dans son ouvrage *Elvis Presley : A Complete Reference*. Les ventes rapporteront 26 millions de dollars dès la première année.

1956–1958 Trois films font d'Elvis une star du grand écran : *Le Cavalier du crépuscule* (1956), *Le Rock du bagne* (1957) et *Bagarres au King Creole* (1958).

1958 Décès de sa mère. Le soldat de deuxième classe Elvis Presley, matricule US53310761, obtient une permission pour se rendre à son chevet.

Août 1959 Il rencontre Priscilla Beaulieu à Bremerhaven, en Allemagne de l'Ouest.

1960–1967 Dégagé des obligations militaires, Elvis tourne une série de films kitsch qui ne se distinguent guère les uns des autres : *Sous le ciel bleu de Hawaï* (1961), *Le Shérif de ces dames* (1962), *Un direct au cœur* (1962), *Des filles, encore des filles* (1962) …

1er mai 1967 Épouse Priscilla à Las Vegas.

Février 1968 Naissance de sa fille Lisa-Marie.

3 décembre 1968 Participe à une émission spéciale à la NBC, énergique et prometteuse.

21 décembre 1970 Est reçu amicalement à la Maison blanche par le Président Richard Nixon, qui lui remet une carte d'agent fédéral de la brigade des stupéfiants.

1971–1977 Elvis se renfloue avec une série de concerts à Las Vegas qui ne méritent pas d'être inscrits dans les annales. En proie à une lourde dépendance aux médicaments, il prend du poids et sa santé se détériore gravement.

16 août 1977 Elvis est retrouvé mort à 14h30, après avoir succombé à une crise cardiaque. Il s'était isolé dans sa salle de bains privée dans la matinée, en emportant le livre *A Scientific Search for the Face of Jesus*.

PORTRAIT (1956)

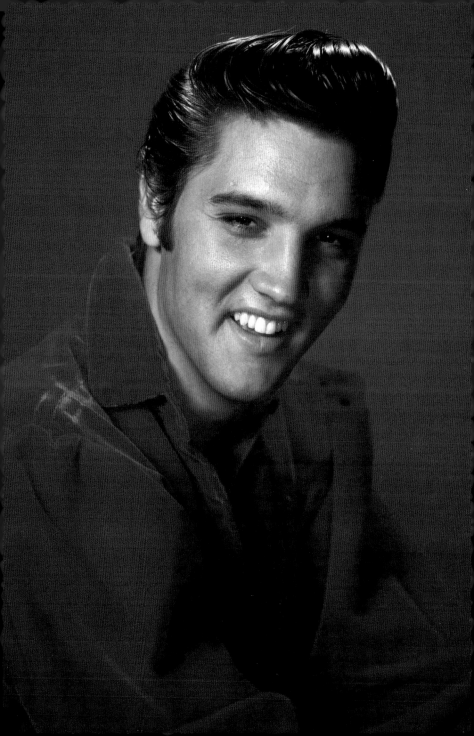

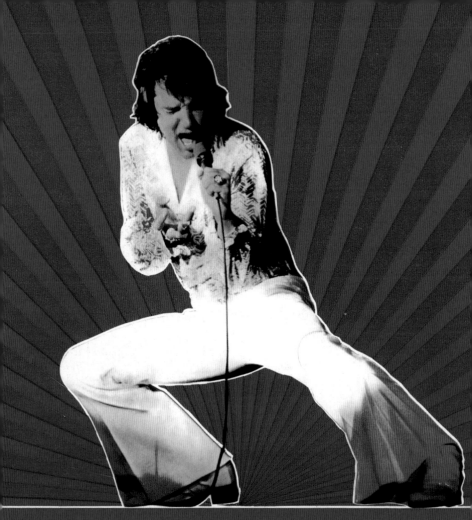

MGM presents

ELVIS
ON TOUR

Produced and Directed by **PIERRE ADIDGE** and **ROBERT ABEL** Metrocolor

4
FILMOGRAPHY

FILMOGRAFIE

FILMOGRAPHIE

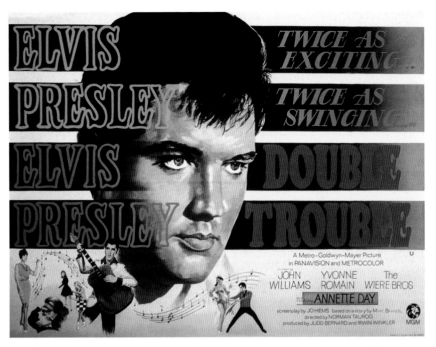

Love Me Tender (dt. *Pulverdampf und heiße Lieder*, fr. *Le Cavalier du crépuscule*, 1956)
Clint Reno. Director/Regie/réalisation: Robert D. Webb.

Loving You (dt. *Gold aus heißer Kehle*, fr. *Amour frénétique*, 1957)
Jimmy Tompkins (Deke Rivers).
Director/Regie/réalisation: Hal Kanter.

Jailhouse Rock (dt. *Rhythmus hinter Gittern*, fr. *Le Rock du bagne*, 1957)
Vince Everett. Director/Regie/réalisation: Richard Thorpe.

King Creole (dt. *Mein Leben ist der Rhythmus*, fr. *Bagarres au King Creole*, 1958)
Danny Fisher. Director/Regie/réalisation: Michael Curtiz.

G.I. Blues (dt. *Café Europa*, fr. *Café Europa en uniforme*, 1960)
Tulsa McLean. Director/Regie/réalisation: Norman Taurog.

Flaming Star (dt. *Flammender Stern*, fr. *Les Rôdeurs de la plaine*, 1960)
Pacer Burton. Director/Regie/réalisation: Don Siegel.

Wild in the Country (dt. *Lied des Rebellen*, fr. *Amour sauvage*, 1961)
Glenn Tyler. Director/Regie/réalisation: Philip Dunne.

Blue Hawaii (dt. *Blaues Hawaii*, fr. *Sous le ciel bleu de Hawaï*, 1961)
Chad Gates. Director/Regie/réalisation: Norman Taurog.

Follow That Dream (dt. *Ein Sommer in Florida*, fr. *Le Shérif de ces dames*, 1962)
Toby Kwimper. Director/Regie/réalisation: Gordon Douglas.

Kid Galahad (dt. *Harte Fäuste, heiße Liebe*, fr. *Un direct au cœur*, 1962)
Walter Gulick. Director/Regie/réalisation: Phil Karlson.

Girls! Girls! Girls! (fr. *Des Filles, encore des filles,* 1962)
Ross Carpenter. Director/Regie/réalisation: Norman Taurog.

It Happened at The World's Fair (dt. *Ob blond, ob braun,* fr. *Blondes, brunes, rousses,* 1963)
Mike Edwards. Director/Regie/réalisation: Norman Taurog.

Fun in Acapulco (dt. *Acapulco,* fr. *L'Idole d'Acapulco,* 1963)
Mike Windgren. Director/Regie/réalisation: Richard Thorpe.

Kissin' Cousins (dt. *Die wilden Weiber von Tennessee,* fr. *Salut, les cousins,* 1964)
Josh Morgan & Jodie Tatum. Director/Regie/réalisation: Gene Nelson.

Viva Las Vegas (dt. *Tolle Nächte in Las Vegas,* fr. *L'Amour en quatrième vitesse,* 1964)
Lucky Jackson. Director/Regie/réalisation: George Sidney.

Roustabout (dt. *König der heißen Rhythmen,* fr. *L'Homme à tout faire,* 1964)
Charlie Rogers. Director/Regie/réalisation: John Rich.

Girl Happy (dt. *Kurven-Lilli,* fr. *La Stripteaseuse effarouchée,* 1965)
Rusty Wells. Director/Regie/réalisation: Boris Sagal.

Tickle Me (dt. *Cowboy-Melodie,* fr. *Chatouille-moi,* 1965)
Lonnie Beale/Panhandle Kid.
Director/Regie/réalisation: Norman Taurog.

Harum Scarum (dt. *Verschollen im Harem,* fr. *C'est la fête au harem,* 1965)
Johnny Tyronne. Director/Regie/réalisation: Gene Nelson.

Frankie and Johnny (dt. *Frankie und Johnny,* fr. *Frankie et Johnny,* 1966)
Johnny. Director/Regie/réalisation: Frederick De Cordova.

Paradise, Hawaiian Style (dt. *Südsee-Paradies,* fr. *Paradis hawaïen,* 1966)
Rick Richards. Director/Regie/réalisation: Michael D. Moore.

Spinout (dt. *Sag niemals ja,* fr. *Le Tombeur de ces dames,* 1966)
Mike McCoy. Director/Regie/réalisation: Norman Taurog.

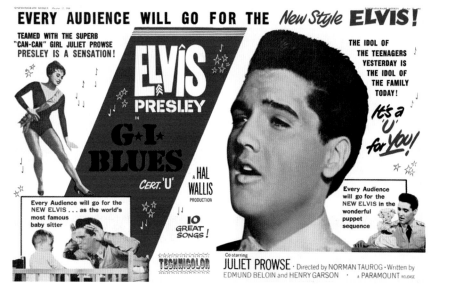

Easy Come, Easy Go (dt. *Seemann, ahoi,* fr. *Trois gars, deux filles et un trésor,* 1967)
Ted Jackson. Director/Regie/réalisation: John Rich.

Double Trouble (dt. *Zoff für zwei,* fr. *Croisière surprise,* 1967)
Guy Lambert. Director/Regie/réalisation: Norman Taurog.

Clambake (dt. *Nur nicht Millionär sein,* 1967)
Scotty Hayward/'Tom Wilson'.
Director/Regie/réalisation: Arthur H. Nadel.

Stay Away, Joe (dt. *Harte Fäuste, heiße Lieder,* fr. *Micmac au Montana,* 1968)
Joe Lightcloud. Director/Regie/réalisation: Peter Tewksbury.

Speedway (fr. *À plein tubes,* 1968)
Steve Grayson. Director/Regie/réalisation: Norman Taurog.

Live a Little, Love a Little (dt. *Liebling, laß das Lügen,* fr. *Le Grand Frisson,* 1968)
Greg Nolan. Director/Regie/réalisation: Norman Taurog.

Charro! (dt. *Charro,* 1969)
Jess Wade. Director/Regie/réalisation: Charles Marquis Warren.

The Trouble with Girls (dt. *Immer Ärger mit den Mädchen,* fr. *Filles et show-business,* 1969)
Walter Hale. Director/Regie/réalisation: Peter Tewksbury.

Change of Habit (dt. *Ein himmlischer Schwindel,* 1969)
Dr. John Carpenter. Director/Regie/réalisation: William Graham.

Elvis: That's the Way It Is (1970)
Himself/Elvis Presley/dans son propre rôle.
Director/Regie/réalisation: Denis Sanders.

Elvis On Tour (1972)
Himself/Elvis Presley/dans son propre rôle.
Directors: Robert Abel, Pierre Adidge.

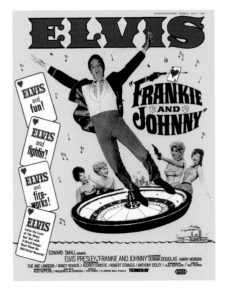

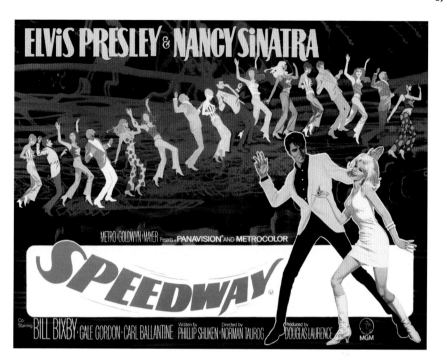

BIBLIOGRAPHY

Braun, Eric: *The Elvis Film Encyclopedia, an impartial guide to the films of Elvis.* The Overlook Press, 1997.

Brown, Peter Harry & Broeske, Pat H.: *Down at the End of Lonely Street.* Dutton, 1997.

Doll, Susan: *The Films of Elvis Presley.* Publications International, 1991.

Dundy, Elaine: *Elvis and Gladys.* Macmillan, 1985.

Esposito, Joe & Oumano, Elena: *Good Rockin' Tonight, 20 years on the road and on the town with ELVIS.* Simon & Schuster, 1994.

Farren, Mick & Marchbank, Pearce: *Elvis, in his own words.* Omnibus Press, 1977.

Flippo, Chet: *Graceland, the living legacy of Elvis Presley.* CollinsBooks, 1993.

Guralnick, Peter: *Last Train to Memphis, the rise of Elvis Presley.* Little, Brown, 1994.

Guralnick, Peter: *Careless Love, the unmaking of Elvis Presley.* Little, Brown, 1999.

Haining, Peter (ed.): *Elvis in Private, with contributions by John Lennon, Ann-Margret, Priscilla Presley, etc.* St. Martin's Press, 1987.

Krogh, Egil "Bud": *The Day Elvis Met Nixon.* Pejama Press, 1994.

Marcus, Greil: *Dead Elvis, a chronicle of a cultural obsession.* Doubleday, 1991.

Presley, Priscilla Beaulieu (with Sandra Harmon): *Elvis and Me.* Putnam, 1985.

Sauers, Wendy (ed.): *Elvis Presley, A Complete Reference: Biography, Chronology, Concerts List, Filmography, Discography, Vital Documents, Bibliography, Index.* McFarland, 1984.

Tobler, John & Wooten, Richard: *Elvis, the Legend and the Music. The complete illustrated biography of his life, his films, his songs.* Crescent Books, 1983.

Torgoff, Martin (ed.): *The Complete Elvis.* Putnam, 1982.

Vellenga, Dirk (with Mick Farren): *Elvis and the Colonel.* Delacorte Press, 1988.

Whisler, John A.: *Elvis Presley, reference guide and discography.* Scarecrow Press, 1981.

Whitmer, Peter: *The Inner Elvis, a psychological biography of Elvis Aaron Presley.* Hyperion, 1996.

Worth, Fred L. & Tamerius, Steve D.: *Elvis, his life from A to Z.* Random House, 1990.

Zmijewski, Steven & Zmijewski, Boris: *Elvis, the films and career of Elvis Presley.* Citadel Press, 1976.

IMPRINT

© 2008 TASCHEN GmbH
Hohenzollernring 53, D-50672 Köln
www.taschen.com

Editor/Picture Research/Layout: Paul Duncan/Wordsmith Solutions
Editorial Coordination: Martin Holz and Mischa Gayring, Cologne
Production Coordination: Nadia Najm and Horst Neuzner, Cologne
German Translation: Thomas J. Kinne, Nauheim
French Translation: Claire Reach, Paris
Multilingual Production: www.arnaudbriand.com, Paris
Typeface Design: Sense/Net, Andy Disl and Birgit Reber, Cologne

Printed in Italy
ISBN 978-3-8228-2323-1

To stay informed about upcoming TASCHEN titles, please request our magazine at www.taschen.com/magazine or write to TASCHEN, Hohenzollernring 53, D-50672 Cologne, Germany, contact@taschen.com, Fax: +49-221-254919. We will be happy to send you a free copy of our magazine which is filled with information about all of our books.